IMAGES
of America
HOUSTON
1860–1900

On the Cover: During a relaxing Sunday afternoon, the women of the House-Howze family pose for a portrait on the lawn of their home in Houston. The second child on the left with dark hair is Mary Louise Howze; the girl in plaid is her sister, Ruth Howze; and the older woman on the lawn is Mary Ann "Mollie" Nicholson McDowell. On the porch are Edith Ruth "Tauntie" House (left) and Edith Ellen "Teeny" Howze Hartung. (Courtesy of SallyKate Marshall Weems.)

IMAGES
of America
HOUSTON
1860–1900

Ann Dunphy Becker

ARCADIA
PUBLISHING

Copyright © 2010 by Ann Dunphy Becker
ISBN 978-0-7385-6683-2

Published by Arcadia Publishing
Charleston, South Carolina

Printed in the United States of America

Library of Congress Control Number: 2009937670

For all general information contact Arcadia Publishing at:
Telephone 843-853-2070
Fax 843-853-0044
E-mail sales@arcadiapublishing.com
For customer service and orders:
Toll-Free 1-888-313-2665

Visit us on the Internet at www.arcadiapublishing.com

To my mother, Virginia Cooney Dunphy, who taught me the importance of the past, and to my children, Charlie and Mary, through whom our history will continue. Finally, to my husband, who kept the home fires burning while I wrote this book.

Contents

Acknowledgments		6
Introduction		7
1.	The Civil War and After	9
2.	Rebuilding the City	37
3.	High Cotton Returns	61
4.	Spark into the Future	101
Bibliography		126
Index		127

ACKNOWLEDGMENTS

In 1998, Eloise Annette "Nettie" Burke reached from beyond the grave and gave me the opportunity to carry on her slice of Houston history. The following people in alphabetical order have been more than helpful, and I'm thankful for their patience, insight, and understanding of the importance of this time period in Houston history: James Daniel Becker, Charles Dain Becker, Mary Allison Becker, Leslie Ballew, Sandy Bruce, David Bush, Robert P. Cochran, Alice Colette, Sarah R. Duncan, Deborah Duty, Carolyn Farmer, Kirk Farris, Nelson Fernandez III, Jim Fisher, Patty Gambino, Stephen Griffin, Patti Heininger, Virginia Kirkland Innis, Beth Leney, Gail M. Miller, DeEtte Dupree Nesbitt, Michaeline Lusk Norton, Judy Rosenthal, Wallace Saage, Kay Sharp, Anne Sloan, Ellen Stuart, Maria Becker Troegel, Janet K. Wagner, and SallyKate Marshall Weems.

INTRODUCTION

This book has four chapters filled with photographs depicting Houston's story from 1860 to 1900. The first chapter will depict people who survived the Civil War and its aftermath, remained in Houston, and started businesses and families. The second chapter takes a look at how the economy was rebuilt and what infrastructures were put into place that assisted the new growth. It also looks at some of the organizations that played a part in stabilizing the citizenry to allow for collective planning. The third chapter demonstrates the continued growth of families, businesses, and organizations. Finally, chapter four illustrates Houston's spark into the future and how the way was paved for Houston as we know it today.

As a city of 5,000, Houston, Texas, had a blossoming economy in 1860, sporting over 330 miles of radiating railroad track. The city exported almost three times as much cotton as it had in 1857. While, unfortunately, slavery did exist in Houston during this period, there was a lower rate of slave ownership than in eastern states. During the Civil War, Houston continued to grow and prosper, being removed from the actual fighting and damage from the war and managing to outwit the Union blockaders. Having a well-worn road access to Mexican ports, the city merchants sent Texas cotton to European ships waiting at Mexican ports in exchange for Cuban bananas and sugar, Jamaican rum, French linen, New York fresh garden seeds, foreign gunpowder, and British *sabots*. The wealthy Houston merchants simply relocated to Matamoras, Monterrey, and Tampico to continue a booming trade with British, European, and Caribbean ports. Galveston merchants like William Pitt Ballenger moved to Houston for the duration. Houston became the center of the trans-Mississippi region war supply, acting as a manufacturing and transportation center. As Houston was headquarters for the Texas, New Mexico, and Arizona War District, William Robinson Baker offered his large home at the south end of town for Gen. John B. Magruder's headquarters.

The period in Houston's history encompassed in this book begins with the Civil War years and the devastated economy of the city that followed. The photographs go on to depict the subsequent rebuilding of Houston's infrastructure as a collective mission and the amazing results yielded by the cooperative efforts of city leaders, businessmen, and citizens. The photographs visually herald the gestation and growth of Houston as a transportation hub and center of the South, culminating with the deepening of the ship channel. The deepening of the channel (a typically "larger than life" Houston goal) and corresponding establishment of an international port resulted in a spark for Houston into the 20th century.

Houston was a vibrant Southern city until February 1, 1861, when Texas seceded from the Union. This secession brought a halt to all new construction and a slowdown to the economy. The threat of invasion was more likely at Galveston, which made Houston a secure supply center for the Confederacy. At the start of the Civil War, Houston had four railroads that radiated northwest, east, south, and southwest. The city was in position to maintain some degree of the commerce that existed prior to 1861.

During the Civil War, against all odds, Houston continued to export cotton to the international market. The city also provided much-needed supplies to the Confederacy and the Confederate army. The city's cotton traveled down Buffalo Bayou and through the Gulf with brave blockade-runners, who then took the cotton on to Mexico. Photographs contained in this text depict the growth, storage, sale, and transport of cotton, which early on dominated Houston's export economy.

Early Houstonians were of tough pioneer stock. Some were immigrants like Thomas W. House and James Robert Cade (from England) or G. A. Forsgard (from Sweden), and some were born in the United States, like Andrew Jackson Burke, Edward Hopkins Cushing, and William R. Baker. All of these men, their wives, and many others appearing in these photographs possessed a unique combination of stubborn individualism graced with the ability to recognize the importance of cooperation and mutual respect to survive the devastation of Houston's postwar economy. All possessed that singular blend of vision and traditionalism that has continued to define the city as it rockets into the future while continuing to respect and remember its past. These citizens were active in the resumption of railroad building, which would transfer Houston into a hub for railways as they joined with Charles Morgan of New York to bypass Galveston and, in the process, to straighten and deepen the ship channel almost to the foot of Main Street, Houston.

The Houston merchants and their families were the visionaries who saw Buffalo Bayou with bridges connecting every part of the city. In their eyes, Houston's international highway began at the foot of Main Street, where White Oak and Buffalo Bayou converged, and traversed Buffalo Bayou all the way to the Gulf of Mexico and foreign ports. Buffalo Bayou was the focus of a deepwater channel that would provide international trade. Following the Civil War, Houston leadership kept one eye on the international waterway and the other on rebuilding an infrastructure to support that and future growth.

Rebuilding infrastructure by these merchants, citizens, and their families was comprised of expanding the railroad lines out and around the city; constructing new dams and roads; opening new banks, hotels, and stables; and supporting new eleemosynary institutions to effect a stronger cultural climate for the city growth and welfare. Infrastructure meant new fire stations to protect the new housing going up in all directions as well as new office and retail spaces, a federal post office, and schools. New York–born architect Eugene Heiner was engaged as a designer for the new Harris County Jail, which attracted additional quality architects to Houston, such as George E. Dickey. The new buildings and shops attracted accountants, engineers, lumbermen, grocers, and craftsmen in addition to those who supplied the trades. Depicted in the photographs are Bagbys, Burkes, Shepherds, Cochrans, Fuquas, Elsburys, and Butes active in this crucial time period in redevelopment, recovery, and family activities.

Toward the end of the 19th century, citizens began to experience the fruits of the rebuilding of the city and state economy. A more genteel time came about for enjoyment of the Victorian lifestyle that invaded Houston decor and architecture. New families and the founders collaborated to provide amenities for culture and comfort. Cotton and railroading continued to dominate the economic market, with adjunct business and factories supporting the community. Deepwater was on the horizon along with electricity and new forms of transportation.

The Root, DeGeorge, Lusk, Aldrette, and Patrenella families depicted in these pages are emblematic of the industrious pioneers who made a commitment to Houston and whose descendants—both in blood and spirit—are here today. From buggy to Model T, the citizens of Houston lived and loved, leaving us with a legacy of Southern hospitality and success.

—Janet K. Wagner

One
THE CIVIL WAR AND AFTER

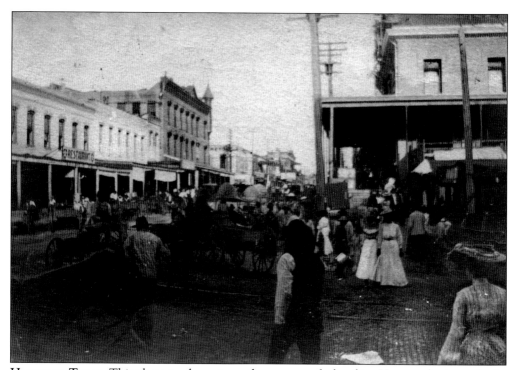

HOUSTON, TEXAS. This photograph captures the essence of a bustling Houston business day in the 1860s. Street vendors stand under canopies selling food to passersby while a wagon drives out of the camera frame after making a delivery. The tracks were built for mule-drawn trolley cars, which along with the installation of gaslights, both graced Houston by 1868. (Courtesy of HoustonHistory.com.)

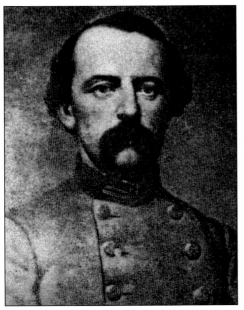

LT. RICHARD W. "DICK" DOWLING. An Irish immigrant, he volunteered to fight for the Confederacy. Dowling disobeyed General Magruder's order to spike the six cannon at Sabine Pass and, with his 40 young men, prevented a Federal invasion force of 5,000 troops from landing on Texas soil. The only medals awarded by the Confederacy went to the men of the Davis Guards for this heroic action. (Courtesy of Ken Franke.)

THE BANK OF BACCHUS. Pictured is an advertisement in the 1866 City Directory for Dick Dowling's saloon at the corner of Main Street and Congress Avenue, which was a very popular place, a Houston institution before Dowling volunteered to fight in the war. Dowling served as a director of the Houston Gas Light Company and helped organize what was probably Houston's first company dedicated to oil exploration. (Courtesy of James Daniel Becker.)

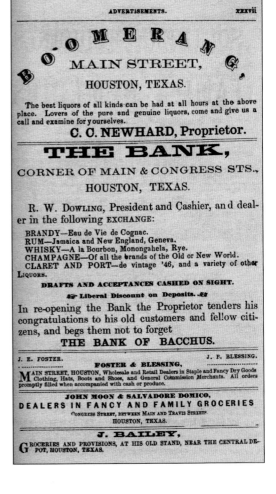

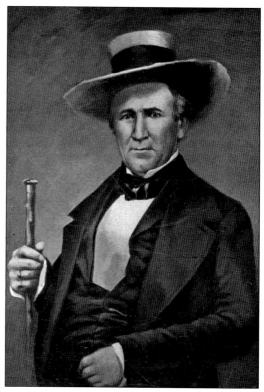

SAM HOUSTON. In 1863, Edward H. Cushing wrote about Houston's passing, "So let us shed tears to his memory, tears that is due to one who has filled so much of our affections. Let his fame be sacredly cherished by Texans, as a debt not less to his distinguished services than to their own honor of which he was always so jealous, and so proud." (Courtesy of SallyKate Marshall Weems.)

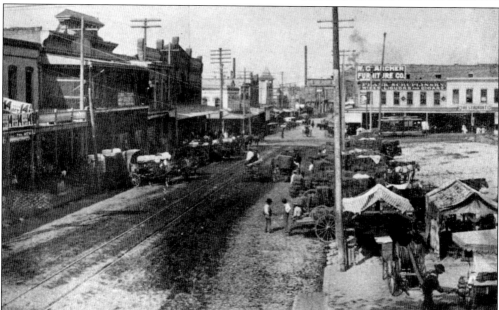

TRAVIS STREET, HOUSTON, TEXAS. Houston was a supply center for the Confederacy. Many families opened their homes to the wounded soldiers and set up makeshift hospital facilities. Cotton, one of the main sources of income at this time, was funneled through Houston to reach the world's markets. In this photograph, cotton merchants line Travis Street waiting to offload their drays. (Courtesy of Robert P. Cochran.)

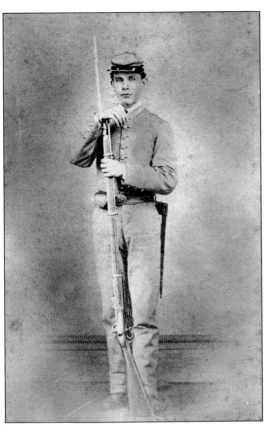

JAMES ALMON GILLETTE. Gillette was 14 when this picture was taken in Sewanee, Tennessee. His rifle is an English infield, imported through Union lines by blockade-runners. After the war, he settled in Houston, raised a family, and opened a law practice. (Courtesy of Patrick and Sherry Irby.)

GILLETTE-FORTRAND LAW FIRM. This firm was located in the Prince Theatre building on Fannin Street between Congress and Preston Avenues facing Courthouse Square. James Almon Gillette (left); his partner, Mr. Fortrand (center); and Judge Ash pose for this photograph taken in 1892. The Gillette family lived in the Houston Heights at the corner of Fifteenth Avenue and Courtland Street. (Courtesy of Patrick and Sherry Irby.)

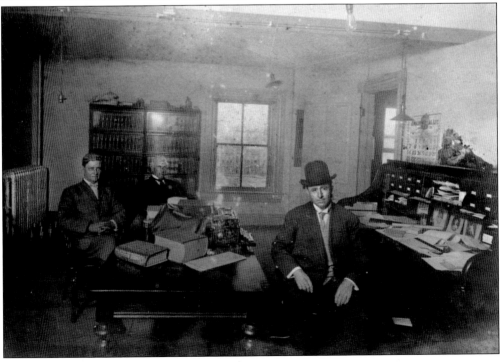

SGT. GEORGE ALBERT BRANARD (1943–1909). George served as a color bearer, Company L, 1st Texas Infantry, Hood's Texas Brigade. He enlisted in 1861, and served valiantly; his comrades remember him by stating, "None was braver than Branard!" At war's end in 1865, he returned home. On April 4, 1866, he married Julia House and they had ten children. (Courtesy of Patricia Branard Gambino.)

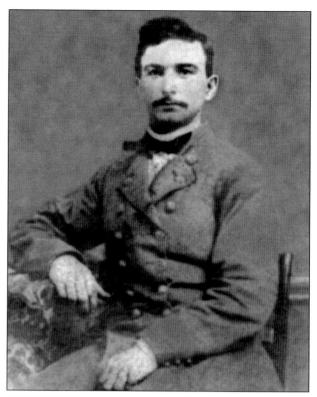

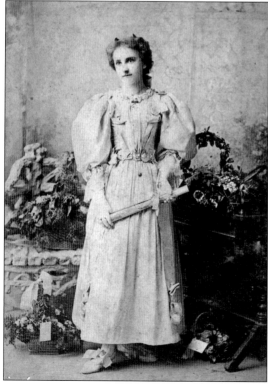

ADA ELIZABETH CONNOR (1878–1945). Ada, a native Houstonian in her 1895 graduation dress from Incarnate Word Academy where she was valedictorian of her class. Her success academically and personally demonstrates the stable economic and social climate of early Houston. In October 1897, Ada married George A. Branard, Jr., an apprentice plumber with the W.W. Otter Co. and later opened his own company, Branard Plumbing. (Courtesy of Patricia Branard Gambrino.)

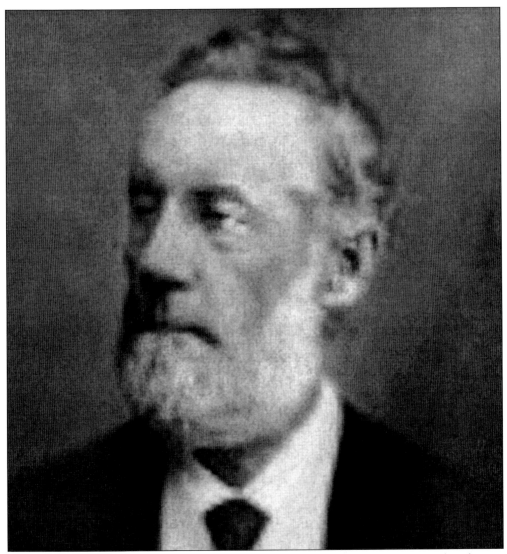

WILLIAM ROBINSON BAKER. Born in New York in 1820, "W. R." moved to Texas when he was about 17 years old. After working two years as a bookkeeper for the Houston Town Company, he worked another two years operating a general store. After that, his career took off. He was elected Harris County clerk when 21 years of age, a post he held for 16 years. Over the course of his life, he amassed a considerable fortune through his various professional endeavors as a Mason, banker, railroad executive, Texas state senator, mayor of Houston, real estate dealer, and land developer. At age 25, he married Hester Eleanor Runnels, daughter of another well-known Houstonian. The couple had one child, Lucy. William R. Baker is buried in Glenwood Cemetery. (Courtesy of J. K. Wagner and Associates.)

EDWARD HOPKINS CUSHING. He was the editor and publisher of the *Telegraph*. During the Civil War, he was forced on occasion to use butcher's paper and wallpaper to keep his press running. Cushing married Matilda Burke, daughter of Reconstruction mayor A. J. Burke. He sold the *Telegraph* but continued operating a book and stationery business, which he ran until his death on January 15, 1879. (Courtesy of Robert P. Cochran.)

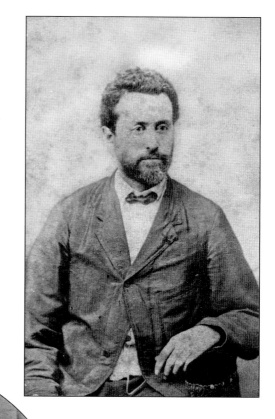

EDWARD BENJAMIN CUSHING (1862–1924). The son of Edward Hopkins Cushing grew up to be president of the board of regents of Texas A&M University. After college, he worked for the Southern Pacific Railroad in Houston, working his way up from ax man to maintenance-of-way engineer. The Texas A&M library was named the Cushing Memorial Library in his honor. (Courtesy of James Daniel Becker.)

MATILDA BURKE CUSHING. She was the daughter of Mayor A. J. Burke and the renowned hostess at Bohemia, the Cushing estate. When her husband, Edward H. Cushing, died in 1879, she and two of her children went to live with her father in his home, leaving Bohemia. (Courtesy of Robert P. Cochran.)

BOHEMIA. The home below was the salon of Houston. Guests at functions here were the literary elite. The flowers at their estate, Bohemia, were among the most complete collections in the United States. The 10 acres of incredible beauty were located where the campus of Houston Community College (HCC), at San Jacinto and Holman Streets, now stands. (Courtesy of Robert P. Cochran.)

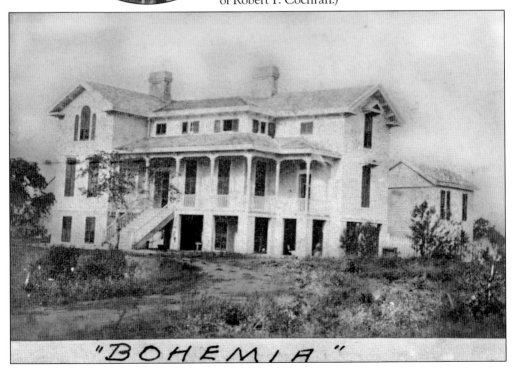

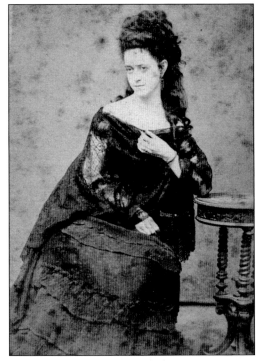

ELOISE ANNETTE "NETTIE" BURKE. She was born in 1854 at home on the corner of Travis Street and Rusk Avenue. In 1869, when she was 15, she kept a diary; from this small volume, a firsthand account of Victorian Houston is possible: "I commence my 2nd journal in Galveston July 8th, 1869. It has been nearly a week tomorrow since I came to Galveston. I am staying with Miss Mollie Moore and she is just as sweet and good as she can be, I never enjoyed myself as much in my life as I have been in the last week." (Mollie Moore was the protégée of her brother-in-law E. H. Cushing and eventually a celebrated Texas author.) This photograph shows two pages of the diary, which was written from July through December 1869. (Both courtesy of James Daniel Becker.)

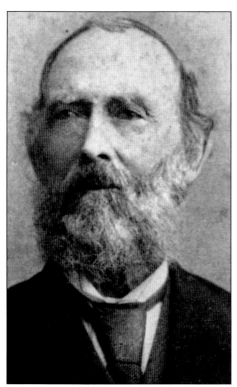

ANDREW JACKSON BURKE (1813–1903). Burke was the Reconstruction mayor of Houston in 1879, a trustee of the First Presbyterian Church, and a county commissioner. He was a director of the Central Railroad and a supporter of the Houston Academy. He served as president of the Planters Mutual Insurance Company with an office located in the Houston Insurance building at the corner of Main Street and Franklin Avenue. (Courtesy of James Daniel Becker.)

ELOISE LUSK BURKE. She was active in the First Presbyterian Church Ladies Association while her husband was an elder. She was a friend of Zerviah Noble, one of Houston's first schoolteachers. Eloise was a dedicated wife, mother, and one of the women who opened her home to sick and wounded soldiers during the Civil War. Only 5 of her 13 children survived to adulthood. (Courtesy of James Daniel Becker.)

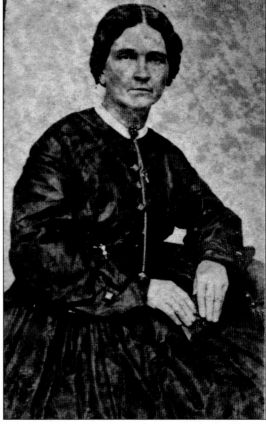

LADIES ASSOCIATION OF THE PRESBYTERIAN CHURCH. These ladies published a cookbook in 1883, "suited to the requirements of our climate . . . and the results, not of theoretic cookery, but of practical testing and approval." This was one of the first cookbooks produced by members of a religious congregation in the state of Texas. It appears that "fritters" were quite a favorite in the Burke home. (Courtesy of SallyKate Marshall Weems.)

FANCY DISHES.

Fritters—Banana.

One quart flour, two eggs, one-half teaspoon salt, two teaspoons yeast powder, sweet milk or water enough to make a stiff batter. Slice six bananas in the batter and fry in boiling lard. MRS. A. J. BURKE.

Orange Fritters.

Make batter as above, and use four medium sized oranges instead of bananas. Peel and chop, and mix with the batter. MRS. A. J. BURKE.

Apple Fritters.

Use chopped apples instead of other fruit. Make the same batter and follow the same directions. MRS. A. J. BURKE.

Plain Fritters.

Make a batter as above, omitting the fruit. Drop from a large spoon in boiling lard, and fry them brown. MRS. A. J. BURKE.

Cheese Fritters.

Three tablespoons of flour, three tablespoons of cheese, one ounce of melted butter, one gill of tepid water, one egg. Put a pinch of salt in the white of the egg to make it froth quickly. Put the flour in a bowl, make a hollow in the middle, and put into it the butter, beaten yelk of the egg, the tepid water, grated cheese and pepper and salt to taste; after stirring well, add the beaten white of egg. MRS. E. R. FALLS.

Apples for Tea.

Pare a dozen or more apples, core them carefully, and fill the centre of each apple with sugar and a small lump of butter. Put them in a pan with half pint water; baste occasion-

xxii ADVERTISEMENTS.

HOUSTON & TEXAS CENTRAL
RAILWAY COMPANY.

WM. J. HUTCHINS, President.
 JAS. F. LOUDON, Sec'y. & Treas'r.
DIRECTORS.—Wm. J. Hutchins, W. R. Baker, A. J Burke, T. W. House, Wm. M. Rice, Cor. Ennis.
Charles A. Burton, Superintendent.
CONDUCTORS.—H. W. Benchley, James Terry.

ARRIVAL AND DEPARTURE OF TRAINS.—Trains leave Houston daily, (Sundays excepted,) on Tuesdays, Wednesdays, Thursdays and Fridays at 9:30 A. M. Reach Hempstead (50 miles) at 2 P. M., connecting with the Washington Co. Railroad to Brenham, 25 miles. Leave Hempstead at 2:15 P. M., and reach Navasota (70 miles) at 4 P. M., connecting with line of stages to Shreveport, tri-weekly, on Mondays, Wednesdays and Fridays. Leaves Navasota at 4:15 P. M., and reaches Millican (80 miles) at 5 P. M., connecting with tri-weekly stages on Mondays, Wednesdays and Fridays, for Waco.

Returning, leaves Millican daily, (Sundays excepted,) on Tuesdays, Wednesdays, Thursdays and Fridays at 7:30 A. M. Reaches Navasota at 8:30 A. M., Hempstead at 10:30 A. M., and Houston at 3 P. M.

On Mondays and Saturdays, the train connects with the Galveston, Houston and Henderson Railroad; leaving at 11 A. M., reaching Hempstead at 3 P. M., Navasota at 4:30 P. M., and Millican at 5:30 P. M.

Returning, leaves Millican on Mondays and Saturdays at 7:30 A. M., reaching Navasota at 8:30 A. M., Hempstead at 10:30 A. M., and Houston at 3 P. M.

STATIONS, DISTANCES AND RATE OF FARE.

				SPECIE.	
From Houston	to Gum Island,	12 miles,	fare	$	60
"	" to Cypress,	25	"	"	1 25
"	" to Hockley,	35	"	"	1 75
"	" to Hempstead	50	"	"	2 50
"	" to Courtney,	62	"	"	3 10
"	" to Navasota,	70	"	"	3 50
"	" to Millican,	80	"	"	4 00

HOUSTON AND TEXAS CENTRAL RAILWAY. An advertisement in the 1866 City Directory lists as directors of the railway T. W. House, A. J. Burke and William R. Baker, among others. These citizens were active in the post–Civil War resumption of railroad building that would transfer Houston into a hub for railways and transportation. (Courtesy of James Daniel Becker.)

19

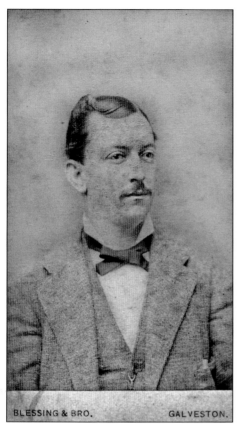

FRANK S. BURKE. Born in Houston in 1848, he graduated from Yale in 1871. He practiced law with Anson Jones and served as a county commissioner, attorney, and counselor of the Supreme Court. In a letter, Frank wrote to a Yale classmate, "I sometimes wonder how I ever went to Yale, for among my earlier recollections, there is very little of schools. Most of them are of riding over the prairies herding cattle, or with a gun and dogs hunting or chasing almost every kind of game until I was past the age of 15 years, when I joined a Cavalry regiment in the Confederate Army and spent one year entertaining the invaders under Generals Banks and Weitzel and the rest of the time on the frontier, holding back the frolicsome Kiowa and Comanche." (Both courtesy of James Daniel Becker.)

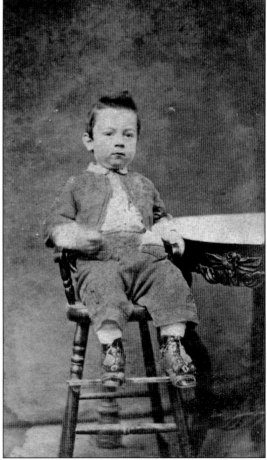

VICTORIAN FASHION. The dresses worn by the young girls—Nettie (left) and Fannie Burke—in this photograph had gathered bodices and ribbon waist ties that accentuate flowing skirts. By 1866, the Howe sewing machine was awarded first place at the New York State Fair, and individual awards were given to clothes sewn by machine. (Courtesy of James Daniel Becker.)

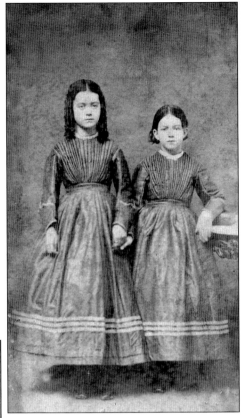

CARTE DE VISITE BACK STAMP. "Carte de visite" means "visiting card" and was a type of photography popular between 1854 and 1880. Many images survived because families kept them in leather albums. Blessing and Brother eventually became Blessing and Brothers, listing both Galveston and Houston as a business location. This back stamp is located on the back of Frank Burke's picture as a young boy. (Courtesy of James Daniel Becker.)

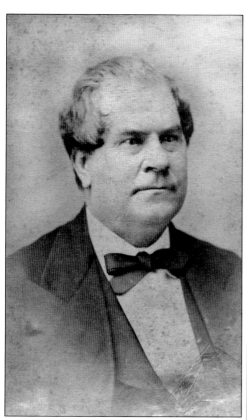

COL. THOMAS WILLIAM HOUSE SR. (1814–1880). In 1838, House began his mercantile career and developed an extensive wholesale trade with the interior. He produced and sold the first ice cream in Houston. House opened a private bank, ran a sugar plantation, and was one of the founders of the Houston and Texas Central Railway. In 1840, he married Mary Elizabeth Shearn, the daughter of Charles Shearn, a chief justice of Harris County. Author Mollie McDowell wrote, "I finally reached Houston and I was distressed to find my good friend, Mrs. House Sr., a victim of the white plague. She was fond of me always, and she was a good mother to my sister. She was so merry, so jolly and loving. Every day I rode out in the carriage with Mrs. House." (Both courtesy of SallyKate Marshall Weems.)

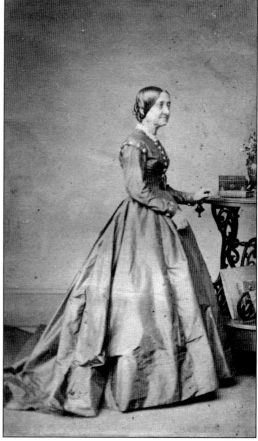

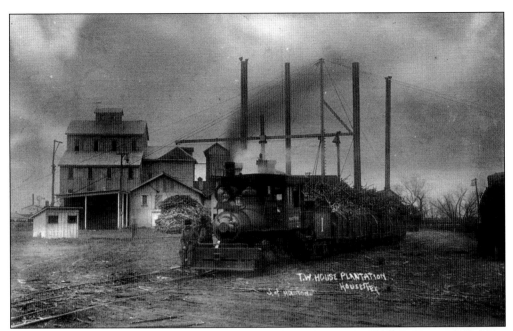

ARCOLA SUGAR PLANTATION. This business was the largest cotton and sugar plantation in Texas in the late 1860s. The Arcola community was formed predominantly by freed slaves and had a post office by 1869. By 1884, the community had a sugar mill, two steam gristmill/cotton gins, two general stores, a Baptist church, and a school. (Courtesy of SallyKate Marshall Weems.)

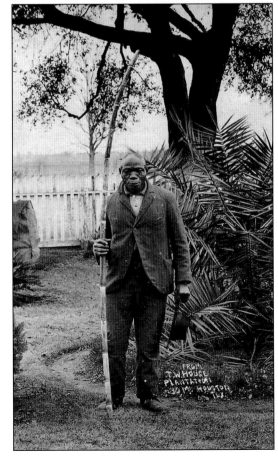

MERRICK BOYCE. Merrick Boyce was a prison trustee on the Arcola Plantation. He worked for Thomas W. House for many years as the plantation foreman. When House was absent, Merrick Boyce had complete command of the operation. (Courtesy of SallyKate Marshall Weems.)

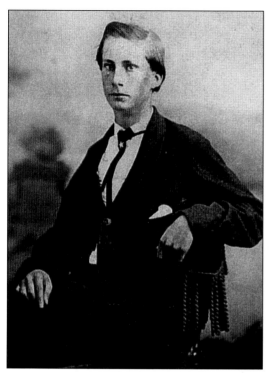

T. W. House Jr. T. W. House Jr. succeeded his father in the banking business and excelled in many other business ventures. In 1882, he was a member of the Houston City Council and his occupation was listed as owner, private bank; cotton broker; president, Houston Gas Light Company; vice president, Houston Water Company; and vice president, Houston East and West Texas Railroad. (Courtesy of SallyKate Marshall Weems.)

Ruth Nicholson House. T. W. Jr.'s future wife, Ruth Nicholson, was born and raised in Bastrop. She died in 1915 after serving the citizens of Houston as president of Faith Home and director and benefactor of the Young Women's Christian Association. She cared deeply about Houston, her adopted home. Without her foresight and financial assistance, the YWCA's existence in Houston would not have been. Ruth and T. W.'s children were Mary, Edith Ruth, Cora, Ellen, T. W. "Will", and J. H. B. "John". (Courtesy of SallyKate Marshall Weems.)

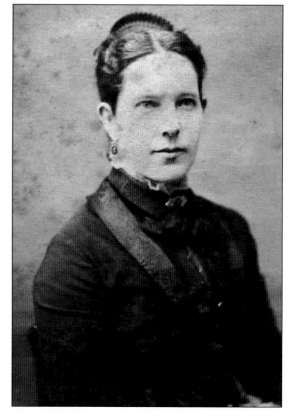

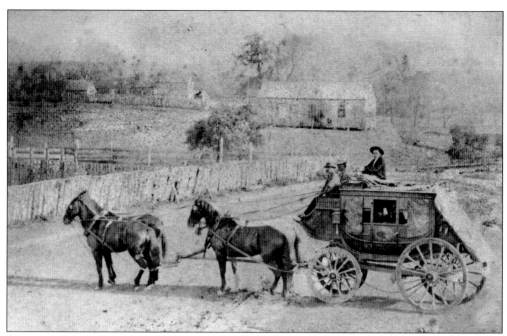

WEDDING PARTY. This stagecoach leaves Bastrop in 1869 with Ruth Nicholson and T. W. House Jr., who were just married. They are settled in for the 10-hour journey to Houston. Upon their return, as testimony of the esteem in which Houstonians held the couple, the young men of the city gave the couple a big reception at Gray's Hall. (Courtesy of SallyKate Marshall Weems.)

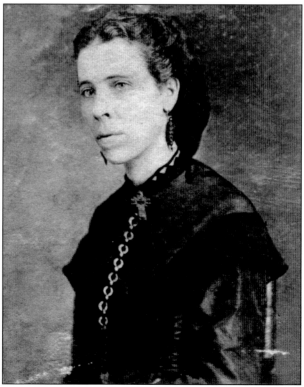

MARY ANN "MOLLIE" NICHOLSON MCDOWELL. An accomplished writer and musician, Mollie was known to play the organ during services at the Methodist or Presbyterian church or the piano at plantation parties or while boating down Buffalo Bayou. She was president of the Young Women's Christian Association and is credited with its establishment in Texas. She is in the cover photograph of this book. (Courtesy of SallyKate Marshall Weems.)

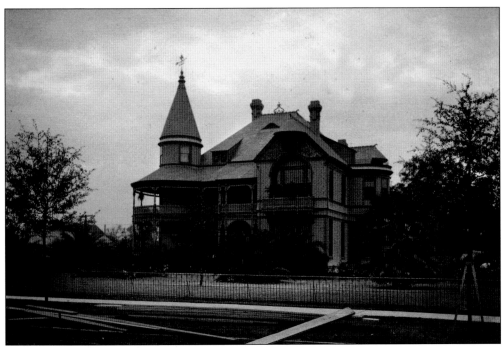

HOME AT 1010 LOUISIANA STREET. The T. W. House Jr. home, located at 1010 Louisiana Street, was built in 1872 and had a huge garden. James Gaughan, the gardener, wrote, "The garden contained every vegetable known to man, with a fig orchard and pecan grove, and palms thirty feet high. Before the Galveston storm, two immense oaks trees graced the town fifty feet in height. The storm completely wrecked these beautiful oaks." (Courtesy of SallyKate Marshall Weems.)

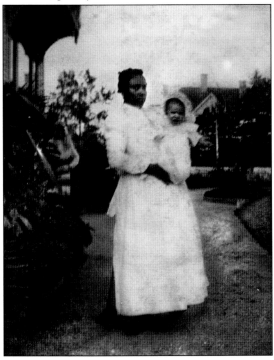

MINERVA GAMEL. Half of all employed women in 1870 worked in private or public housekeeping. Gamel, pictured at left with a House child, lived with the T. W. House Jr. family at their home at 1010 Louisiana Street. Ruth Nicholson House had a large home with six children and, at any one time, as many visitors. Family members stayed for several weeks at a time when visiting. (Courtesy of SallyKate Marshall Weems.)

ELIZA SCOTT. In 1870, the first year the United States listed occupations for women of all ages and races, 1 in every 8.4 families had at least one domestic servant. Scott, pictured here, worked the majority of her life with the House family. (Courtesy of SallyKate Marshall Weems.)

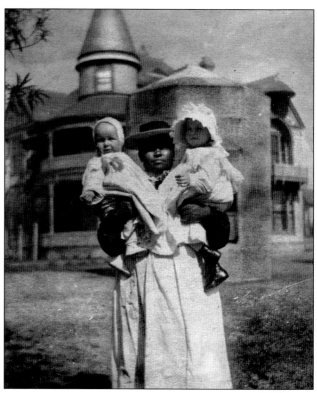

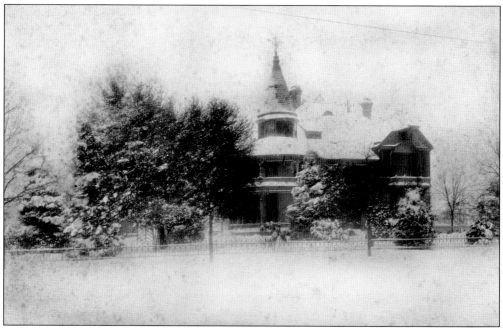

SNOWFALL IN HOUSTON ON FEBRUARY 15, 1895. This was possibly the largest storm Houston ever received. The home at 1010 Louisiana Street disappeared under a blanket of white. The *Galveston Daily News* headline read, "Business Suspended—Street Car Traffic is Completely Stopped—Banks and Wholesale Houses Close Their Doors." (Courtesy of SallyKate Marshall Weems.)

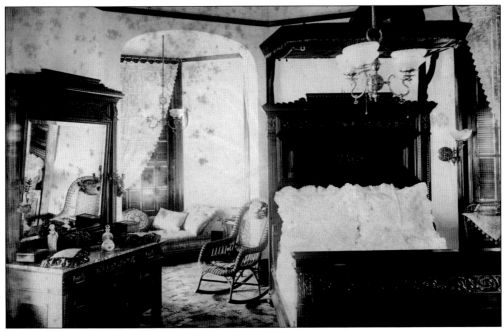

INTERIORS AT 1010 LOUISIANA STREET. Ruth Nicholson House had exquisite taste in decorating. In the bedroom above, the mahogany bed and dresser (with adjustable mirror) rest on brightly colored carpet beneath two hanging gas fixtures. (A fourth, mounted directly by the bedside, allows for bedtime reading.) Beautiful lace curtains accent the windows' wooden shutters. In the dining room below, the mahogany buffet sets an elegant tone for the leather dining chairs with their exquisite wooden carved frames, which in turn blend well with the velvet-backed lace tablecloth. The brass hooked window coverings with three layers of material would have been delightful in warm or cool weather conditions. (Both courtesy of SallyKate Marshall Weems.)

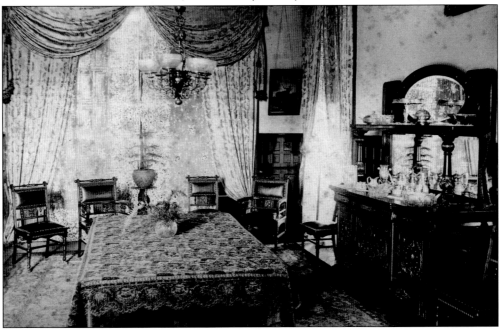

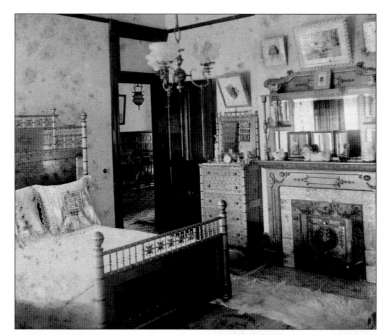

ELLEN AND MARY HOUSE'S ROOM. Ellen and Mary House shared this room furnished in a white and maple-stained bamboo bedroom set. Notice the fur carpet on the floor in front of the marble fireplace and the sweet baby doll on the mantel. Mary, the eldest daughter, and Ellen, the youngest, made good companions. (Courtesy of SallyKate Marshall Weems.)

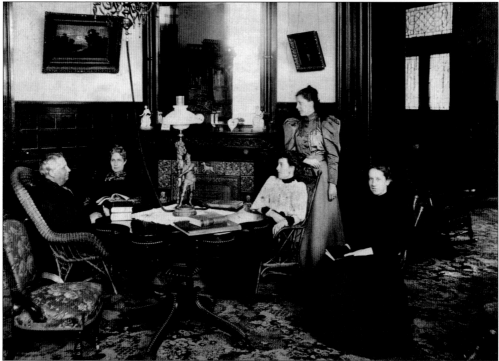

HOUSE FAMILY RELAXING IN THE PARLOR. Victorian family life centered in the family parlor, where hours could be spent reading aloud or playing cards. Tea was served every afternoon in this parlor, a tradition from their English heritage. Each tray had a bowl of fresh fruit, requested by Ruth House for the children. Here, from left to right, T. W. House Jr.; his wife, Ruth Nicholson House; Mary; Ellen; and Edith enjoy an evening together. Notice the gas-fed lamp, which sits on a mahogany table. (Courtesy of SallyKate Marshall Weems.)

EDITH RUTH "TAUNTIE" HOUSE. Edith was a daughter of Ruth Nicholson and Thomas W. House Jr. She was a well-educated and artistically inclined young woman. The wonderful scrapbooks she kept throughout the years demonstrate her commitment to family history and tradition. She and her sister Ellen were the House family "keepers of the records." Many images used in this book are present because of their careful archival nature. (Courtesy of SallyKate Marshall Weems.)

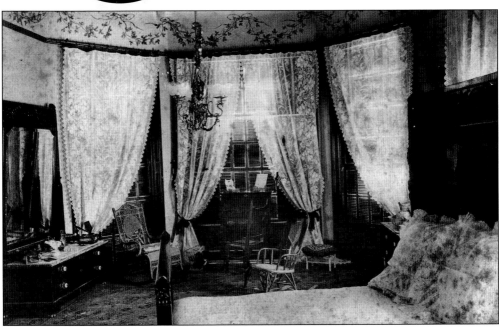

EDITH AND CORA'S BEDROOM. Edith and Cora shared this large room with a mahogany bed with a matching dresser. Edith House, an inspiring artist, took time to embellish the ceiling with a delightful crawling ivy vine pattern. Wooden-dowelled lace curtains elegantly brush the floor in front of wooden shutters. Perfume bottle and ivory jewelry trays sit on the marble-topped vanity. (Courtesy of SallyKate Marshall Weems.)

CORA HOUSE. The daughter of T. W. House Jr., Cora died tragically. The *Galveston Daily* reported "shortly after their arrival (from the North) she was taken with what appeared to be a sore throat, but it turned out to be diphtheria, which it is presumed she contracted on the sleeper while returning home as there were two children aboard who had just recovered from it." (Courtesy of SallyKate Marshall Weems.)

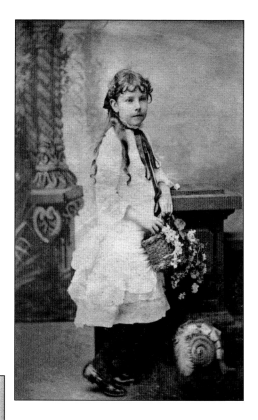

PRESBYTERIAN CHURCH COOKBOOK. Published in 1883, this cookbook gave instructions on how to create Japanese cleaning creams and cologne water, prevent mildew on preserves, and relieve neuralgia and stop nose-bleeds, along with a sure cure for coughs and colds that used a lot of molasses and linseed oil. (Courtesy of SallyKate Marshall Weems.)

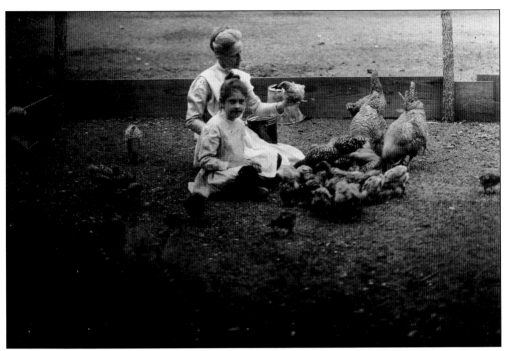

EDITH HOUSE AND MARY LOUISE HOWZE. Most families in the late 19th century raised chickens for their eggs. In this photograph, newborn chicks are entertaining two House family members. Edith and her niece, Mary Louise, sit down to rest after feeding the chickens. Mary Louise appears to be very confident about the task at hand. (Courtesy of SallyKate Marshall Weems.)

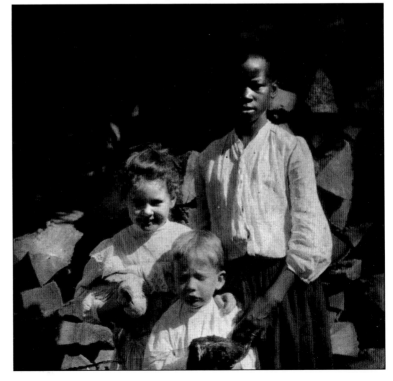

HOUSE FAMILY RELATIVES. Cousins Ruth House Howze and William Lamkin stop playing just long enough to have this picture taken. The unidentified older girl's expression seems to say, "Wait just a minute, hold still." Ruth poses like a professional model undoubtedly aware of just how pretty she is, smiling at the cameraman, while William appears annoyed. (Courtesy of SallyKate Marshall Weems.)

ELLEN HOUSE. This darling child at 5 years old shows the spunk that the House family possessed. Notice her stance: arms folded and leaning into the chair, very businesslike, yet barely noticeable is the little back leg almost dangling as if to secretly play while having to stand so still. (Courtesy of SallyKate Marshall Weems.)

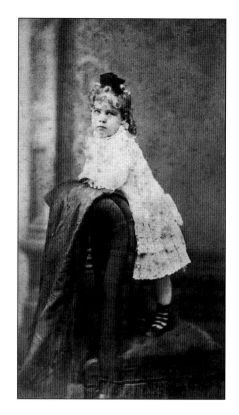

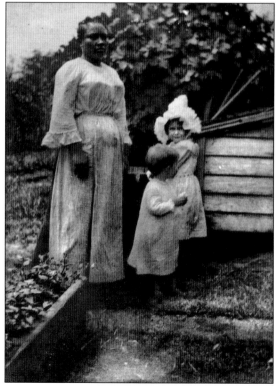

MARY LOUISE HOWZE AND WILLIAM LAMKIN. This unidentified woman caring for the young children looks patient and nurturing. Unlike seamstresses, laundresses, and boardinghouse keepers, who were usually married and relatively independent, domestic servants were generally single women who lived in their employer's house, subject to whatever emergency might arise. (Courtesy of SallyKate Marshall Weems.)

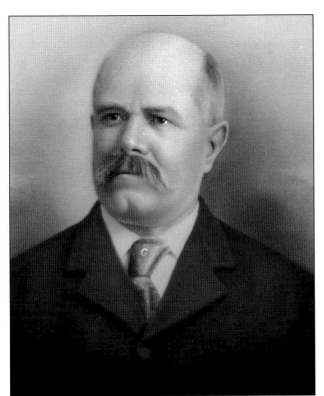

JAMES ROBERT AND ANN MORTIMER CADE. In the 1890s, Cade worked as an innovator or railroad car designer for the Southern Pacific Railroad. He was a prominent Mason and was honored by the naming of the Cade-Rothwell Lodge No. 1151 of Houston, where he was the 16th master mason 1886–1887. He was a leader in the Episcopal Diocese of Texas and instrumental in the founding of the first St. Mary's Church, where he served as senior warden. Originally from England, Cade was the first immigrant to serve as president of the Mechanic's Building and Loan Association and served as a member of the school board during the administration of Mayor H. Baldwin Rice. Cade and his wife, Ann, lived at 1317 Lee Street. (Both courtesy of DeEtte Dupree Nesbitt.)

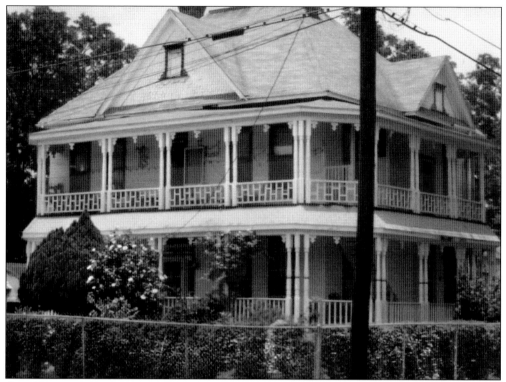

CADE HOME AT 1317 LEE STREET. James Robert Cade was chief car builder for the Southern Pacific Railroad when he built this substantial house. This existing structure reflects Cade's status as a skilled craftsman. It is much larger and more elaborately ornamented than most of the other houses in this working-class neighborhood. (Courtesy of the Greater Houston Preservation Alliance.)

GRAND LODGE MASONIC TEMPLE. On December 20, 1837, the Grand Lodge of Texas was organized. This building hosted Freemasonry in Houston from 1871 to 1905, when individual lodges were formed. A. J. Burke, Robert James Cade, Gustave A. Forsgard, and Edward H. Cushing were but a few Masons who attended meetings here. (Courtesy of Robert P. Cochran.)

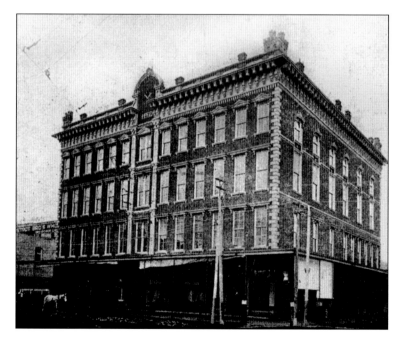

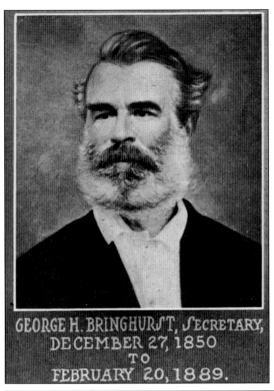

GEORGE H. BRINGHURST. Bringhurst was appointed surveyor of Harris County in 1848. He was secretary of the Houston Town Company and Buffalo Bayou wharf master. He married Nancy Trott, daughter of Elizabeth and Henry Trott. He was secretary and treasurer of the Grand Lodge of Texas for over 20 years and the secretary of Holland Lodge No. 1 for more than 30 years. (Courtesy of James Daniel Becker.)

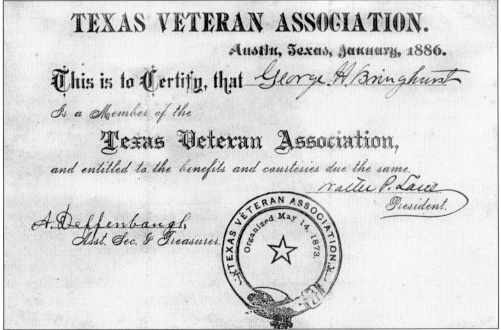

TEXAS VETERANS ASSOCIATION CERTIFICATE. George Bringhurst fought for the Republic of Texas and was captured and held prisoner after the Battle of San Jacinto. He was a member of the Texas Veterans Association and received this certification in 1886, when Walter P. Lane served as president. (Courtesy of Robert P. Cochran.)

Two
REBUILDING THE CITY

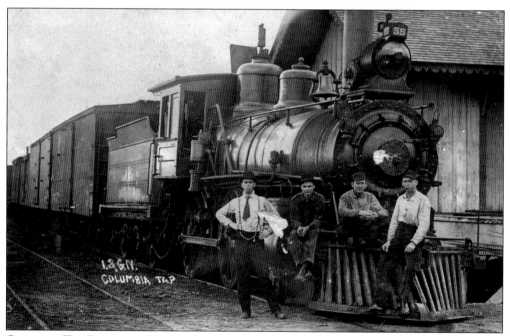

COLUMBIA TAP RAILROAD. The conductor and engineers in this photograph are on the tracks to the Arcola Plantation, which was owned by Thomas W. House Sr. The Houston Tap and Brazoria Railway Company was chartered on September 1, 1856, to run from Houston to Columbia and Brazoria. The railroad was colloquially referred to as the Columbia Tap. (Courtesy of SallyKate Marshall Weems.)

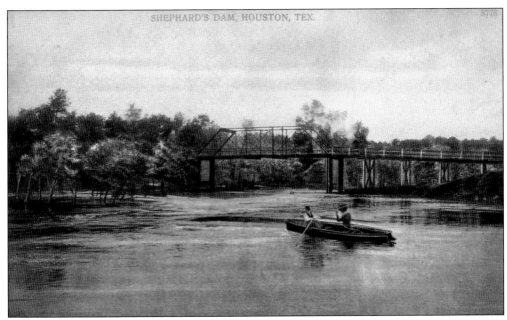

SHEPHERD'S DAM BRIDGE. A bridge built over Buffalo Bayou and Shepherd's Dam Road was a thoroughfare that connected Washington Avenue with San Felipe and Westheimer Roads. Built in 1875 by D. P. Shepherd, a cousin to Benjamin A. Shepherd, this dam backed up the water for nearly three miles. It made a great pleasure resort for Houston. This is where Shepherd Drive is today. (Courtesy of the Heritage Society.)

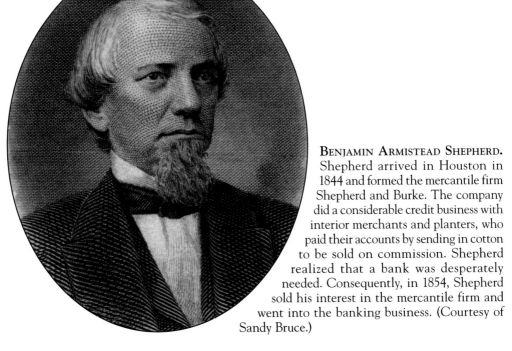

BENJAMIN ARMISTEAD SHEPHERD. Shepherd arrived in Houston in 1844 and formed the mercantile firm Shepherd and Burke. The company did a considerable credit business with interior merchants and planters, who paid their accounts by sending in cotton to be sold on commission. Shepherd realized that a bank was desperately needed. Consequently, in 1854, Shepherd sold his interest in the mercantile firm and went into the banking business. (Courtesy of Sandy Bruce.)

FIRST NATIONAL BANK. This bank was located at 201–205 Main Street at Franklin Avenue. The bank was often referred to as "Shepherd's Bank" because from July 1, 1867, until his death in 1891, Benjamin A. Shepherd was the president. He employed a large number of family members, including sons-in-law Alexander P. Root and Owen L. Cochran. (Courtesy of Robert P. Cochran.)

TEXAS AVENUE AND TRAVIS STREET. This bustling business district in early Houston was home to the land office of J. S. Daugherty. In 1873, he was engaged in all classes of land, including cotton, grain, rice, timber, oil, and mineral lands and city property. His success, in part, was due to his employees, who spoke foreign languages so they could assist immigrants with suitable homes. (Courtesy of James Daniel Becker.)

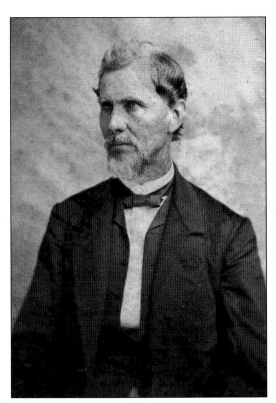

THOMAS M. BAGBY. Bagby was one of nine original members of the Houston Public Library, chartered in 1848, which stands today on the site of the former Bagby home. He was a Mason, Presbyterian, and an alderman of the Fourth Ward. He founded and was president of the Third National Bank, established in Texas. In 1866, he helped form the Houston Direct Navigation Company to promote barge transport of cotton and improve bayou navigation. (Courtesy of James Daniel Becker.)

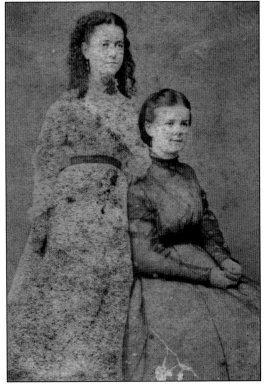

NETTIE BURKE AND NELLIE BAGBY. These native Houstonians were the best of friends, as were their fathers. Nettie (left) and Nellie attended the Houston Academy, an early private school, worshipped at the First Presbyterian Church, and regularly took the train to Galveston to attend festivals.
They represented second-generation Houstonians who would enjoy more opportunity and leisure time than their parents. (Courtesy of James Daniel Becker.)

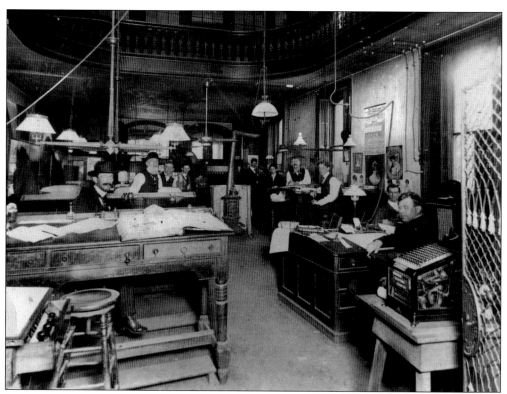

FIRST NATIONAL BANK. In the above picture, bank employees are hard at work during business hours. Displayed are typical items used for account control in early Houston: the large ledger books, drawer full of rubber stamps, and glass-sided adding machines. This type of adding machine used paper tape and printed on a paper tape and first appeared around 1872. The machine pictured here was hand-driven, but some later models replaced the cranks with electric motors. (Courtesy of Robert P. Cochran.)

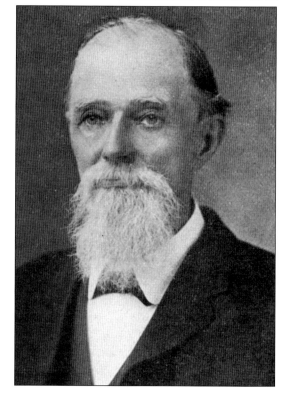

OWEN LYNCH COCHRAN. Vice president of First National Bank, Cochran was regarded as one of the leading financiers and citizens of Houston. He was also an avid reader, debater, and intellectual. When the Houston Academy closed its doors in 1876, it left its large library of over 9,000 books to him, and he donated them to the Houston Lyceum. (Courtesy of Robert P. Cochran.)

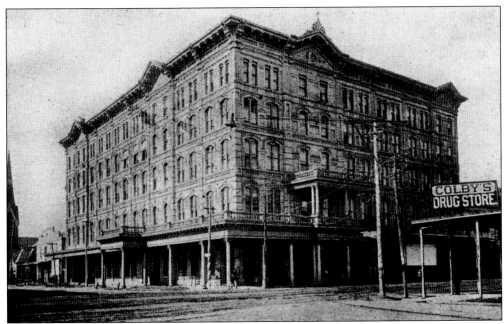

THE CAPITOL HOTEL. The Capitol Hotel was located on the corner of Main Street and Texas Avenue, the site where the provisional capital of the Republic of Texas was located. When the capital was moved to Austin, this hotel was named for what might have been. (Courtesy of Robert P. Cochran.)

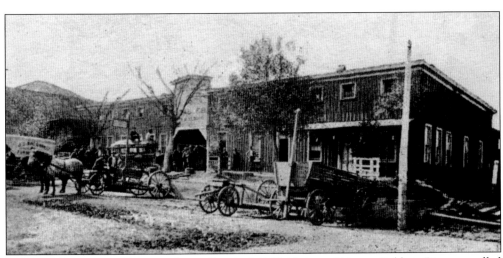

HOUSTON STABLE AND TRANSFER LINE. Cousins J. C. Baldwin and Horace Baldwin Rice controlled most of the hotel trade and contracts for shows appearing in the city. Located at the corner of Congress Avenue and Louisiana Street, this firm devoted its energies to a regular baggage and transfer business, transporting passengers and baggage between all depots and hotels or elsewhere in the city. (Courtesy of James Daniel Becker.)

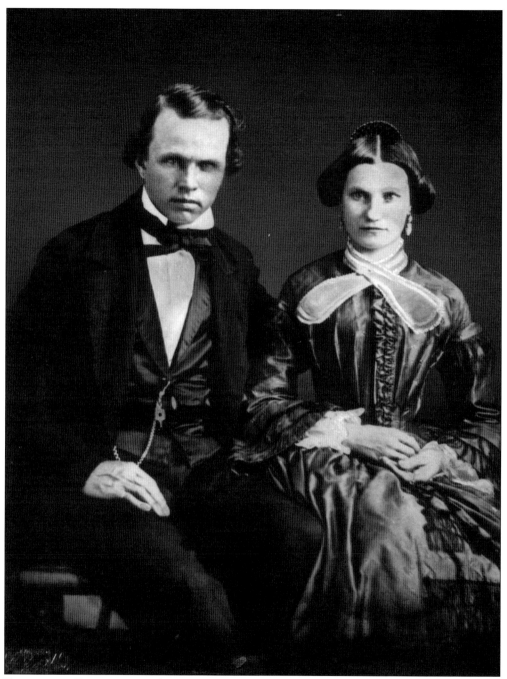

ENGAGEMENT PHOTOGRAPH. Thomas E. Elsbury (1825–1888) and Mary Anne Knight (1834–1906) were married March 10, 1853. This handsome couple was born at Stoke St. Gregory, Somerset, England. Elsbury was engaged in real estate and the hide and leather business. He was a member of Shearn Memorial Church and Holland Lodge No. 1. Mary Anne was the niece of well-known businessman T. W. House Sr. and the daughter of Elizabeth House Knight. (Courtesy of Sarah R. Duncan.)

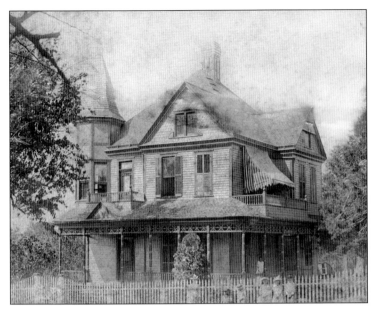

HOME ON THE HILL. The Elsbury home anchored two lots at 501 West Capitol Avenue. The location was commonly referred to as Quality Hill, where palatial homes with lovely gardens were built. Mary Anne Knight Elsbury and her daughter, Bessie, loved to garden. Bessie's favorite flower was Plumbago, a delicate blue flower that could be seen scattered about the Elsbury's grounds. (Courtesy of Sarah R. Duncan.)

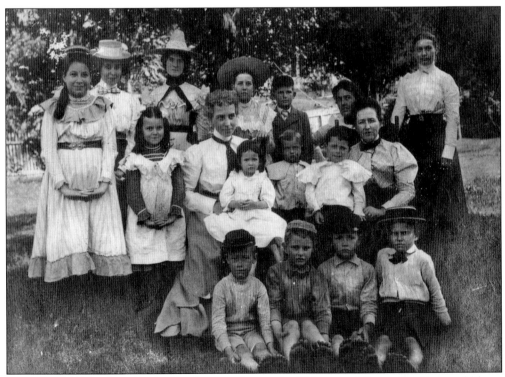

A SUNDAY GATHERING. In the Southern tradition, the Elsbury and Fuqua families would have a grand buffet after church. Following lunch, the men typically retired to the smoking room to light a pipe and discuss world affairs, but the mothers, aunts, and children would gather outside for games and laughter. Children were in bare feet and women in style with cool cotton dresses and summer hats. (Courtesy of Sarah R. Duncan.)

ELSBURY FAMILY PORTRAIT. In the 1870s, this portrait was taken at the Elsbury home at 501 West Capitol Street. Shown are, from left to right, (first row) George Washington, Mary Anne (mother) with baby Thomas Edward, Thomas E. (father), and John William Elsbury; (second row) Bessie, Charles Knight, and Mary Ellen. (Courtesy of Mary Jane Price Sponsel.)

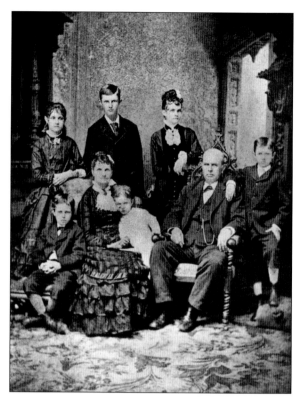

THE HARRIET LANE MIRROR. In the Buchanan administration, First Lady Harriet Lane danced with the Prince of Wales in the main salon, where the mirrors reflected their delight. Shortly afterward, the Confederate navy captured the ship. Owner Thomas W. House auctioned off furnishings and used her as a blockade-runner. Thomas Elsbury purchased the pair of twin mirrors that stood in the grand salon of the *Harriet Lane*, which has been passed down through the Elsbury-Fuqua family for generations. (Courtesy of Louis F. Rothermel II.)

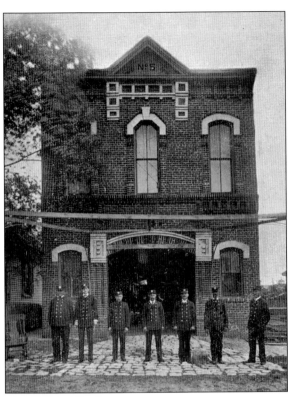

FIRE STATION NO. 5. Fire Station No. 5 was opened by Brooks No. 5 Fire Company on September 24, 1874, on the south side of McKee Street, between Liberty (Rothwell) and Nance Streets. The volunteer fire company had many problems and finally folded in 1883. Eventually, the fire department became a paid force in 1895. (Courtesy of Robert P. Cochran.)

FIRE STATION NO. 5 INTERIOR. This attractive dormitory at Fire Station No. 5 had hot and cold water, which was quite an improvement from earlier station facilities. Notice the mosquito netting for the six beds and the "sweetheart" photographs on the bedside table. (Courtesy of Robert P. Cochran.)

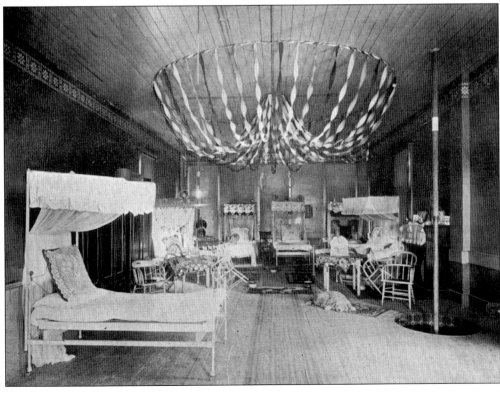

Post Office. U.S. Treasury Department architects had true inspiration when they designed this Moorish-style post office and customs house pictured here—an unusual addition to the Houston skyline. This building stood on the southwest corner of Fannin Street and Franklin Avenue and was completed in 1889. (Courtesy of James Daniel Becker.)

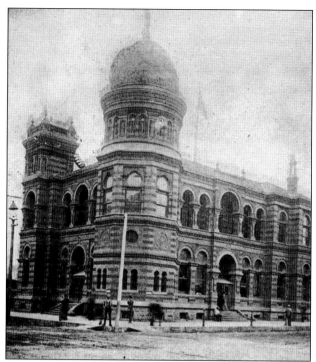

Harris County Jail. This jail at 403 Caroline Street was designed by New York–born architect Eugene Heiner and built in 1879. Heiner also designed the Cotton Exchange Building. Houston's jail was constructed in the Second Empire architectural style popular during the Victorian era. (Courtesy of James Daniel Becker.)

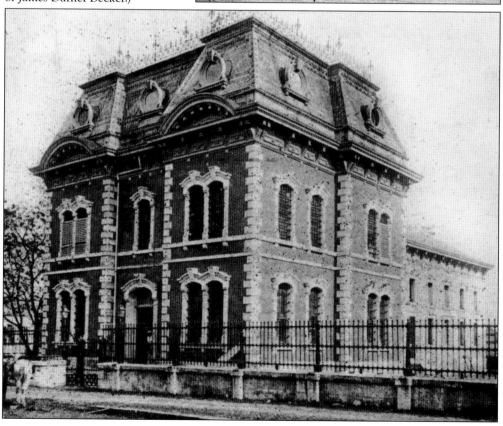

MARY LOUISE HOWZE. Mary Louise is smartly dressed in the latest fashion for young ladies of the upper class. This lovely lace-trimmed riding jacket with decorative cuffs looks tailored to her exact size. A very soft fur muff to keep her delicate Victorian hands warm during carriage rides provides the finishing touch. Her mother, Ellen House Howze, may have purchased this clothing at one of the nicer stores in Houston, like Kiam's. (Courtesy of SallyKate Marshall Weems.)

THE KIAM BUILDING. Located on the corner of Main and Preston Streets, this building was constructed in 1893 for Ed Kiam, a Houston clothier. This five-story building was the first in Houston to have an electric passenger elevator and was designed in 1893 by H. C. Holland, an English architect. Barry Moore Architects restored the Kiam Building in 1981. (Courtesy of James Daniel Becker.)

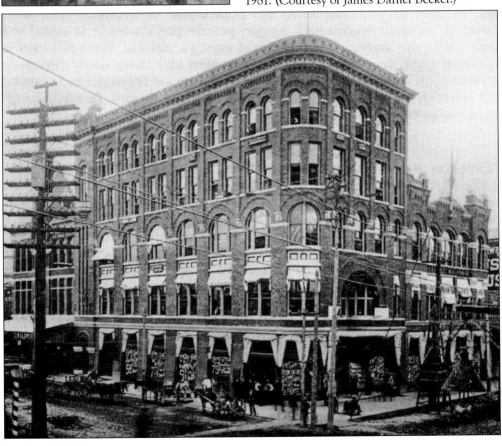

JAMES BUTE. James Bute was prominent in all aspects of merchant supply. He shipped goods by ox train from Houston to Mexico City on a regular basis. Founded in 1867, the James Bute Company was a large general warehousing distributor of wall coverings and canvas, eventually specializing in paint. Bute also ran a local framing shop, which manufactured picture frames from raw moldings. (Courtesy of Patty and Sal Gambino.)

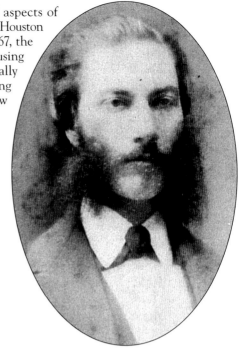

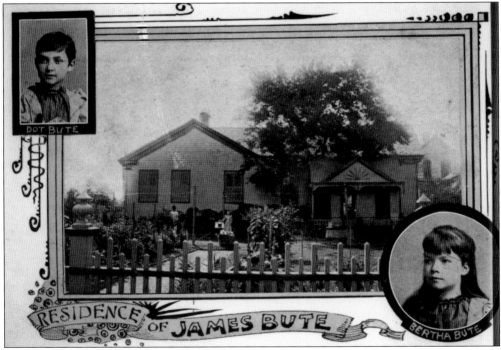

THE JAMES BUTE HOME AND FAMILY. *Galveston Daily News* on July 18, 1897, announced "Mr. and Mrs. James Bute, Mrs. John F. Garrott, Mrs. John Bute and Misses Bertha and Dot Bute have gone to Canada for the summer." Any Houstonian who could afford to leave the sweltering heat of the summer for cooler weather took loved ones and traveled north. (Courtesy of Houston Metropolitan Research Center.)

A Life Cut Short. Josephine Natalie Fuqua Geiselman was the beautiful daughter of Joseph Watkins Fuqua and Charlotte Lydia Valentine Fuqua. She died of pneumonia at the age of 24 in 1883 and was buried in Glenwood Cemetery. Natalie married Michael Pierce Geiselman on January 15, 1879. Early Houstonians were vulnerable to diseases that have been almost eradicated, including diphtheria and yellow fever. (Courtesy of Sarah R. Duncan.)

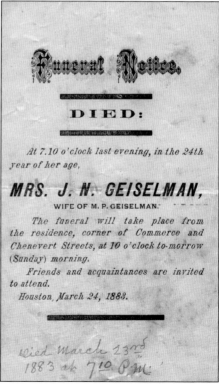

Geiselman Obituary. Throughout much of the 19th century, funerals were, of necessity, kept very simple and concluded very quickly. Services were almost always held in the home of the deceased. This funeral was held at the home of Josephine and Michael Geiselman on the corner of Commerce Avenue and Chenevert Street. (Courtesy of Sarah R. Duncan.)

THE FUQUA FAMILY BIBLE. Before modern technology made genealogical research easier and faster, the family Bible was the receptacle of important records, making it an excellent example of primary source documentation. According to this bible page, these early family members were buried at Founder's Cemetery and Glenwood Cemetery. Many descendants of the family reside in Houston today. (Courtesy of Ellen R. Stuart.)

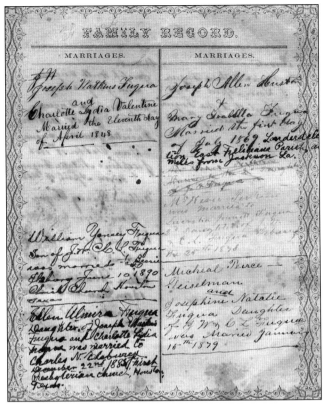

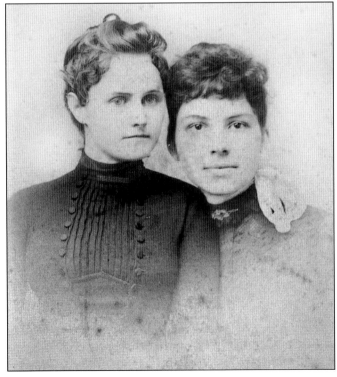

SISTERS-IN-LAW. In this 1886 picture are Bessie Lucile House Elsbury (left) and her sister-in-law Alma Eugenia Fuqua. Bessie married William Yancey Fuqua, but "Miss Alma," a woman born ahead of her time, never married and was the longtime trusted assistant to John Henry Kirby of Kirby Lumber Company. (Courtesy of Ellen R. Stuart.)

JOSEPH WATKINS FUQUA. Fuqua served in the Civil War in Cole's Cavalry and "Carter's Minute Men." Fuqua was the first superintendent of Bayland Orphan's Home for Boys and hired Mrs. Krezia DePelchin as first matron of the home. He dedicated many of his later years to the children of Confederate veterans. Joseph married Charlotte Lydia Valentine in 1848, and they had eight children. (Courtesy of Joseph Watkins Elsbury Jr. and Peter G. Evans.)

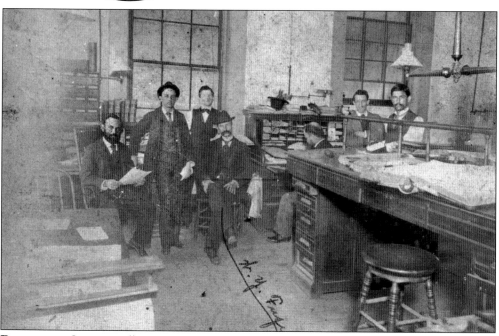

DOWNTOWN OFFICE. William Yancey Fuqua is pictured here with a hat on his head. This may be a law firm judging from the law journals on the far wall or an early location for his real estate ventures. Notice the map table with the gas-fed lighting fixtures, and it must be winter as the men are dressed for cold weather. (Courtesy of William G. Rothermel Jr.)

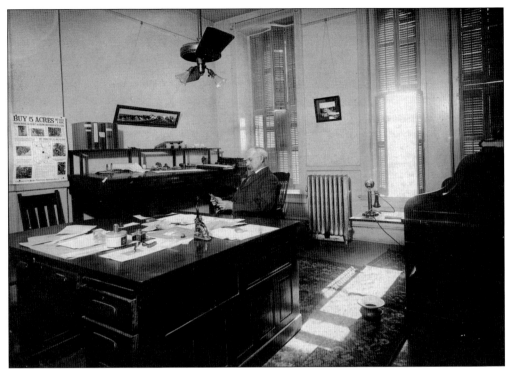

REAL ESTATE OFFICE. At the age of 16, William Yancey Fuqua was promoted to general auditor of the Houston Cotton Press and later was associated with Kirby Lumber Company and Wm. D. Cleveland and Company. He experienced the progress and success of Houston in the real estate business—both commercial and residential—with his office in the Lumberman's Bank Building. (Courtesy of Sarah R. Duncan.)

WILLIAM YANCEY FUQUA. William was the son of Joseph Watkins and Charlotte Valentine Fuqua. William married Bessie Lucile House Elsbury in 1890, and they had eight children. (Courtesy of Ellen R. Stuart.)

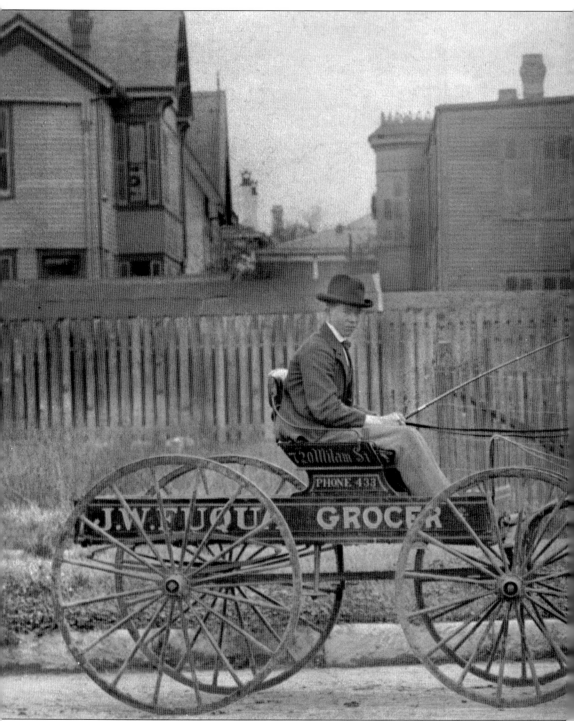

THE DELIVERY WAGON. During Houston's early years, groceries were delivered to homes and businesses once or twice a day, depending on whether or not the customer had a large cellar or icebox. Servants sometimes walked to the Farmer's Market for fresh produce and fruit at nearby Market Square. Here is one of the employees of J. W. Fuqua Grocer, who had an establishment at

702 Milam Street. Joseph Watkins Fuqua knew that, to stay competitive, it was important to give excellent personal service. Notice the well-dressed deliveryman, sure to leave a good impression on any household. (Courtesy of Louis F. Rothermel II.)

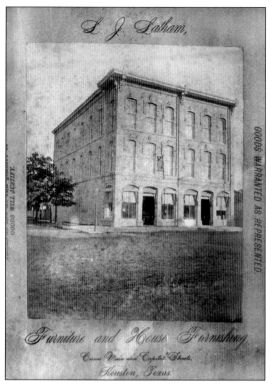

L. J. Latham Furniture and House Furnishings. Capt. Lodowick Justin Latham's business was located at the corner of Main Street and Capitol Avenue. It was one of the largest furniture and hardware stores in Houston. Latham was a seasoned sea captain and noted blockade-runner with business matters that took him as far as China, the West Indies, and ports of Europe. (Courtesy of James Daniel Becker.)

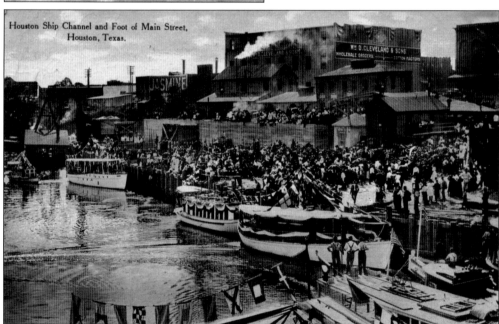

W. D. Cleveland Warehouse at the Foot of Main Street. William D. Cleveland was fortunate enough to own this warehouse at the foot of Main Street from which to business. He advertised that "superior advantages in freights to and from this place make it the cheapest and best location for all classes of merchandise." Cleveland was the second president of the Houston Cotton Exchange and Board of Trade. (Courtesy of Gail Miller.)

JUSTINA LATHAM CLEVELAND AND CHILDREN. A reporter for the *Cincinnati Enquirer* writing from Long Branch observed the Cleveland family on vacation: "W. D. Cleveland, the Houston millionaire, who is at the Ocean Hotel, with his wife, six children and three nurses. They are about to leave for the White Mountains. Think of such a snug little family party." (Courtesy of Houston Metropolitan Research Center.)

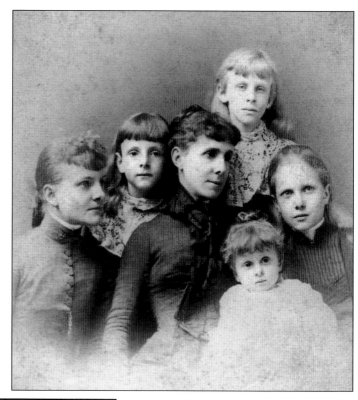

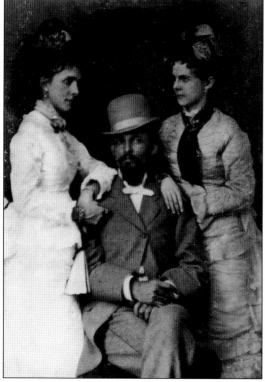

JUSTINA LATHAM AND W. D. CLEVELAND. The Latham-Cleveland courtship was quite unusual. W. D. Cleveland went to the Latham home and announced to Justina's sea captain father, Ludovic J. Latham, that if Justina would like to marry him, she should come outside. After a short wait, she did, and they were married. Pictured with W. D. and Justina is Aline Cleveland (right), W. D. Cleveland's sister. (Courtesy of Houston Metropolitan Research Center.)

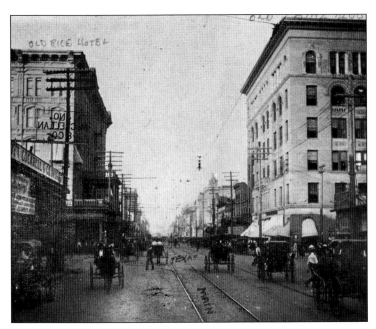

MAIN STREET LOOKING NORTH FROM TEXAS AVENUE. Here is a glance into the Houston business district. A. J. Binz and J. J. Settagast Jr.—real estate, rental, and loan agents—occupied the Binz building (on the right), Houston's first up-to-date office building. It had electric lights, bells, office connections, sewerage, and plumbing of the modern style. The cost of the building when completed was $150,000. (Courtesy of Robert P. Cochran.)

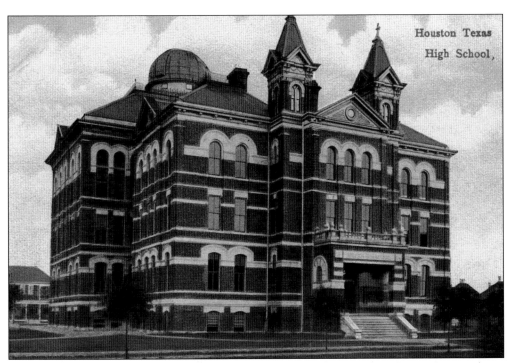

HOUSTON HIGH SCHOOL. This 1893 building by Eugene Heiner replaced the Houston Academy, or Clopper Institute, on the block bounded by Capitol Avenue, Austin Street, Rusk Avenue, and Caroline Street. The HHS newspaper, the *Aegis*, began publication in 1889. (Courtesy of J. K. Wagner and Company.)

PRINCE BUILDING. Located on Fannin Street between Congress and Preston Avenues, facing Court House Square, this was Hyman Prince's entertainment palace. It was first opened as Gray's Opera House, then Sweeney and Coombs' Opera House, then the Houston Theatre, and finally, the Prince. Acts such as Sarah Bernhardt, Maude Adams, and James Hackett headlined at this venue. (Courtesy of James Daniel Becker.)

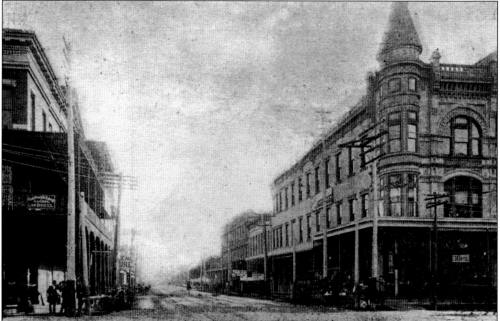

CONGRESS AVENUE LOOKING EAST. On the right is the Sweeney, Coombs, and Fredericks Building. Notice the round turret of this Victorian building, which was built by architect George E. Dickey. Constructed in the 1860s, it was rebuilt and redesigned in 1889 and is now on the National Register of Historic Places. The Sweeney, Coombs, and Fredericks Building is still located at 302 Main Street, on the corner of Congress Avenue. (Courtesy of Robert P. Cochran.)

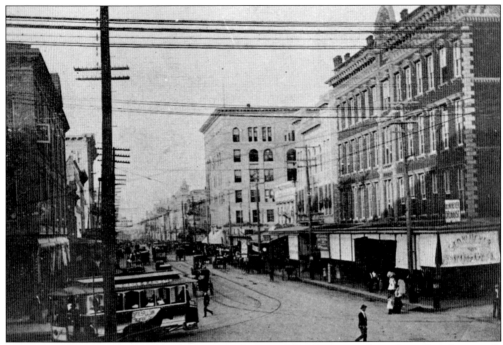

MAIN STREET LOOKING NORTH FROM CAPITOL AVENUE. The awning on the right in this photograph advertises George Meyer Druggist. George was the second generation of this family to be in the retail business. His father, Joseph Meyer, had the largest heavy hardware business in the South. (Courtesy of Robert P. Cochran.)

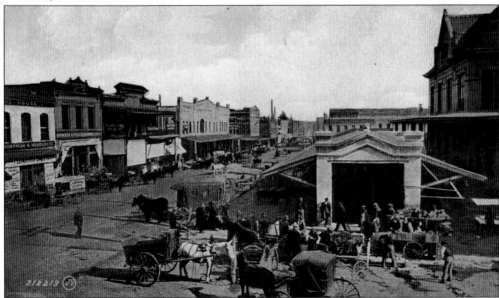

MARKET HOUSE SQUARE. This area bound by Congress Avenue, Travis and Milam Streets, and Preston Avenue would have held the future Halls of Congress if the capital of the Republic of Texas had remained in Houston. Instead, it became an open market place. This view is looking down Milam Street where Grossman and Mendlovitz sold dry goods and Henke and Pillot had their grocery. (Courtesy of Gail Miller.)

Three
HIGH COTTON RETURNS

ALEXANDER P. ROOT AND HIS COUSIN BUD TAYLOR. Alexander (left) lived in Houston and Bud Taylor lived in Brazoria County, so the two would meet at the Eagle Lake Rod and Gun Club to go hunting. In Houston, there were several vacation spots that catered to hunters. These men were avid outdoorsmen, and in this picture, they are dressed for fall weather. (Courtesy of Sandy Bruce.)

ROOT HOME. Built in 1894, the Alexander P. Root home was located at 1400 Clay Avenue. The east side of downtown was filled with sprawling homes, huge gardens, and wealthy Houstonians. This is an example of the residential style of architect George Dickey, who designed the home in 1893. Today this property is a city park with a gazebo and sculpture by local artisans. (Courtesy of Sandy Bruce.)

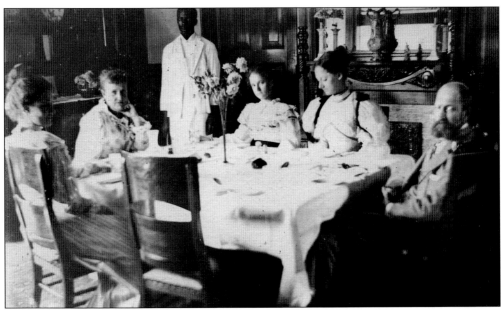

DINING IN THE ROOT HOME. Laura Shepherd Root sits opposite her husband, Alexander P. Root. Daughter Mary Porter sits to her right, and across the table sit daughters Stella (left) and Cora. Here they are enjoying a family meal with Victorian formality. As with most "Quality Hill" families, the Roots employed domestic staff. In the background, a butler stands poised to facilitate the meal. (Courtesy of Sandy Bruce.)

RELAXING ON THE PORCH. The Root home was built with the Houston climate in mind. In this photograph, Alexander P. Root poses with five unidentified women and a darling barefoot girl. Porches were a European custom adopted by those living in the hot Texas climate. Deep porches furnished with rocking chairs were a good way to stay cool during the summer months. (Courtesy of Sandy Bruce.)

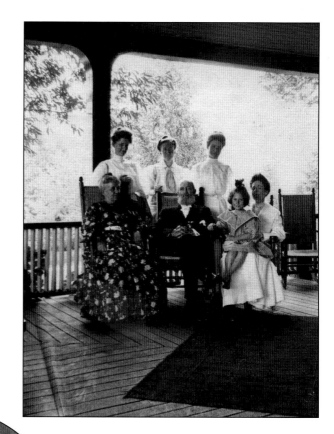

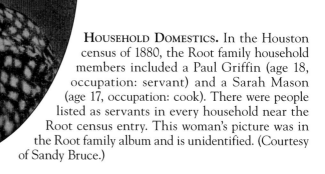

HOUSEHOLD DOMESTICS. In the Houston census of 1880, the Root family household members included a Paul Griffin (age 18, occupation: servant) and a Sarah Mason (age 17, occupation: cook). There were people listed as servants in every household near the Root census entry. This woman's picture was in the Root family album and is unidentified. (Courtesy of Sandy Bruce.)

GEORGE RUTHVEN BRINGHURST. Bringhurst worked as a bookkeeper for City Bank and as secretary and treasurer of the City of Houston. His future wife, Nettie Burke, wrote in her diary, "I would give any thing if I could get acquainted with him, I believe every girl in town has been in love with George Bringhurst; every one that he is acquainted with him any way, he is so handsome and so graceful." (Courtesy of James Daniel Becker.)

NATHANIEL P. TURNER. In the year 1869, Capt. N. P. Turner was proprietor of the Hutchins House. He was married to Anna, the sister of Tom and George Bringhurst. While still a young man, he was known as the Beau Brummel of Houston, a most sought-after bachelor. (Courtesy of James Daniel Becker.)

Tom Bringhurst. The son of George H. and Nancy Trott Bringhurst, Tom was an independent businessman. In 1895, he had a real estate office at 313 Main Street. Nettie wrote about Tom, "I don't want to have to dress myself this evening[;] if it was Tommy Bringhurst that I expected and knew he was coming I would be up and dressed in a few minutes." (Courtesy of James Daniel Becker.)

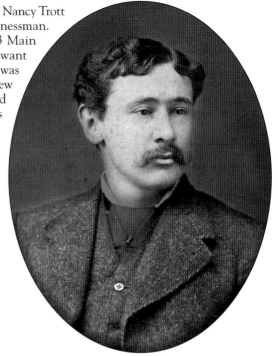

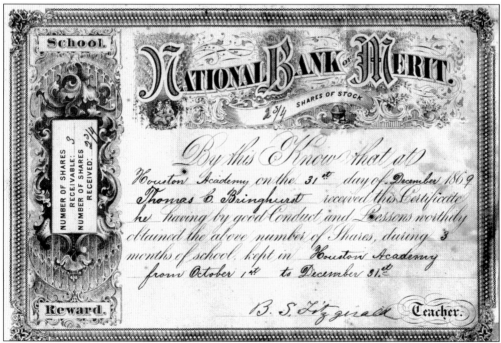

Houston Academy. The Houston Academy, a private school in operation until 1876, had a considerable library of over 9,000 volumes. This is a wonderful piece of ephemera, documenting the attention B. S. Fitzgerald paid to his students. Apparently, Tom Bringhurst was a pretty good student, earning almost the maximum three shares of merit for good conduct and lessons in a three-month period. (Courtesy of Robert P. Cochran.)

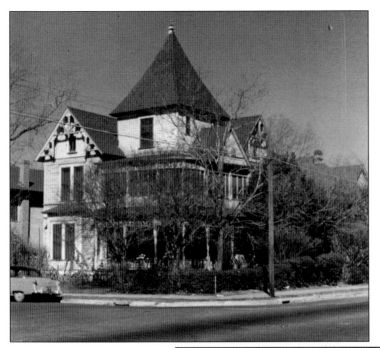

BRINGHURST HOME. This home located at 2716 Milam Street was built in an area of Houston known as the fairgrounds. In this home, George Ruthven and Annette "Nettie" Bringhurst raised their three children and lived out their lives. This fine old home was the setting of many funerals, and two generations of this family lived here until its demolition. (Courtesy of James Daniel Becker.)

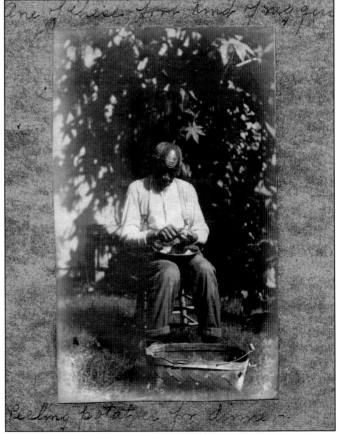

JOE. This gentleman appears twice in the Bringhurst family photo albums identified as "Joe" and "Uncle Joe." The pictures taken of him were outdoor shots, this one of him peeling potatoes and another one posing in a coat with a cane. Non-family household members in some instances were treated no differently than blood-related members, with their pictures displayed in the family album. (Courtesy of Robert P. Cochran.)

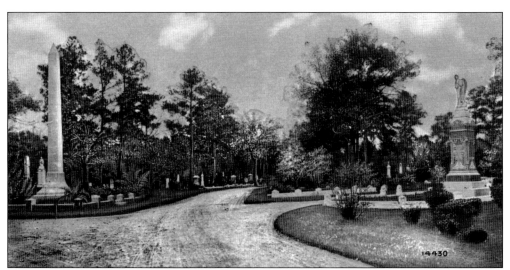

GLENWOOD CEMETERY. Located on the Wynn family homestead, this was the first cemetery in Houston to be professionally designed. Glenwood shares characteristics of other 19th-century romantic garden cemeteries: it was established in a rural area and it was built on a site with a distinguishing natural feature. Glenwood's design takes advantage of the ravines leading to Buffalo Bayou to create a rolling landscape unique in Houston. (Courtesy of Gail M. Miller.)

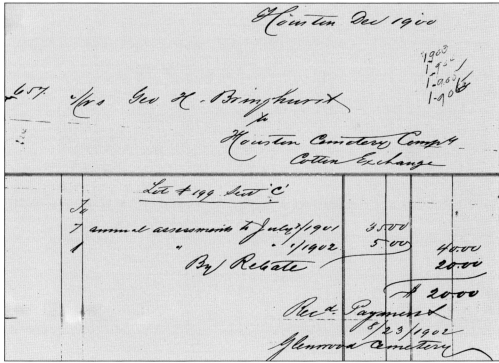

GLENWOOD CEMETERY RECEIPT. Glenwood Cemetery was established as a private cemetery in 1871 by the Houston Cemetery Company, which was incorporated by an act of the Twelfth Legislature of the State of Texas on May 12, 1871. After construction, Glenwood opened for business in the summer of 1872. This receipt shows George Ruthven Bringhurst buying a section for his family, which is today the Burke plot. (Courtesy of Robert P. Cochran.)

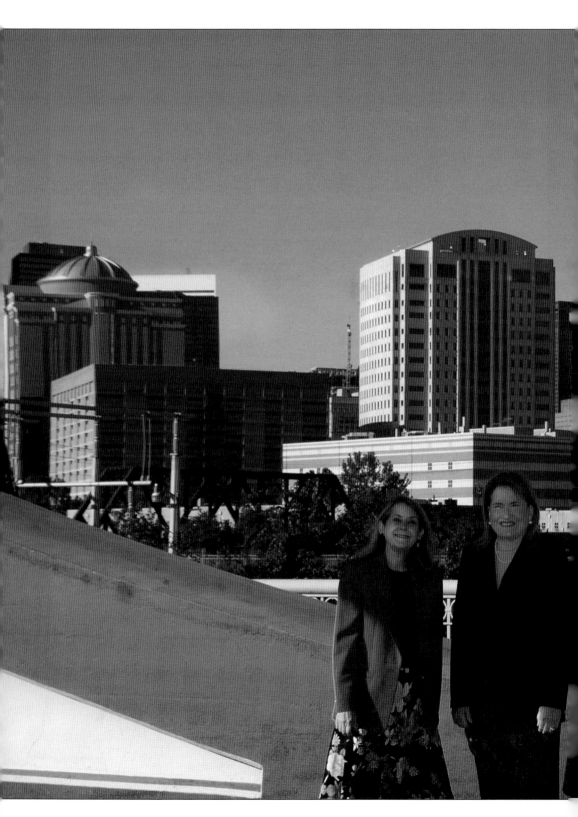

McKee Street Bridge. Pictured here standing on the McKee Street Bridge with the downtown skyline in the background is the Honorable Kathy Whitmire (left), mayor of Houston during the 1980s, and commissioner Sylvia Garcia, who is, in 2010, Harris County commissioner in Precinct 2. In the mid 1980s, environmental artist Kirk Farris rejuvenated the McKee Street Bridge with private grant funding and the full support of then mayor Whitmire. In the process, Farris became both historian and preservationist and Art & Environmental Architecture, Inc. (a nonprofit) was founded. This organization and Precinct 2 are working together to establish a more garden-like environment at this urban location. The foot of McKee Street was discovered to be the location of Houston's first subdivision, Frost Town. Frost Town was carved out of six blocks with nearly 25 lots of land, which were sold to settlers in 1837 and 1838. Today the Frost Town historic site is part of James Bute Park. This park is just one of the projects Commissioner Garcia and Precinct 2 will include in a preservation program called A Barrio History Walk.

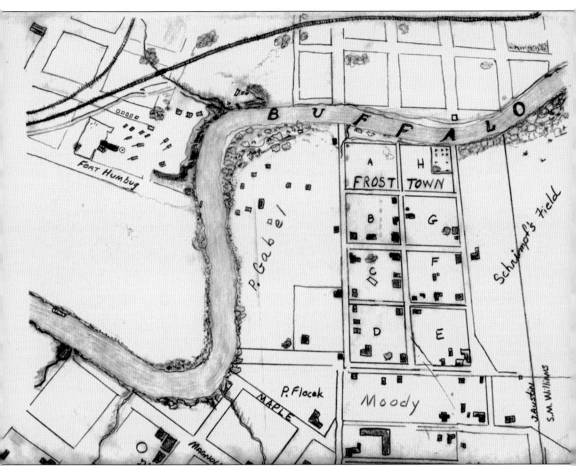

FROST TOWN. This illustration by Kirk Farris shows the location of a little-known Confederate fortification called Fort Humbug. If Union soldiers had tried to sail up Buffalo Bayou to downtown Houston, they would have met with cannon fire. This map also gives the location for the first subdivision in Houston, Frost Town. This area was named for Samuel Frost, its first settler. (Courtesy of Kirk Farris.)

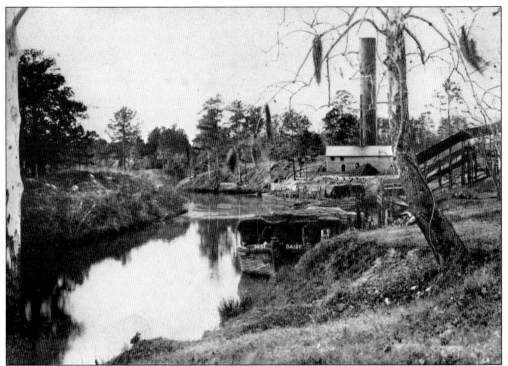

CRYSTAL ICE FACTORY. The Crystal Ice Factory, shown here, supplied ice to pack the early refrigeration cars of the railroads. They also sold electric charges to nearby customers and were part of the Bayou Compress Complex. The barge *Daisy* is docked after loading cotton. To the left of this picture was the settlement of Frost Town in the 1890s. (Courtesy of Kirk Farris.)

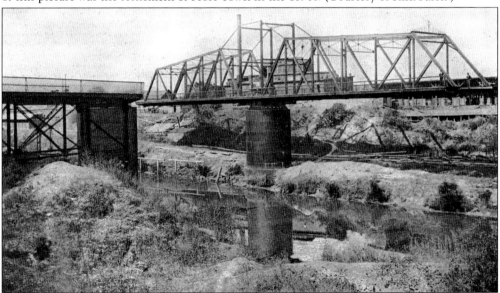

MCKEE STREET BRIDGE. This *c.* 1900 swing bridge opened up to allow tall riverboat traffic upstream above this point at Frost Town to the turning basin at the intersection of White Oak and Buffalo Bayou at the foot of Main Street. The iron footings of the turret are still visible under the present-day McKee Street Bridge, built in 1932. (Courtesy of Kirk Farris.)

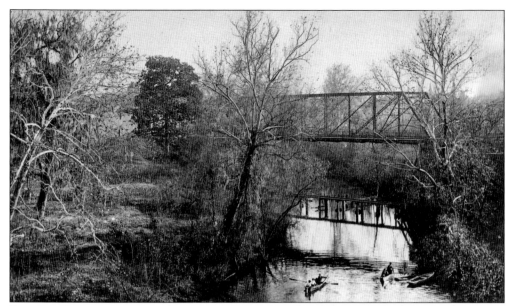

PRESTON AVENUE BRIDGE. The Preston Avenue Bridge today is in the heart of downtown Houston near the Hobby Center. Imagine the serenity during a lazy Sunday afternoon row on Buffalo Bayou. In the late 1800s, the banks of Buffalo Bayou were filled with every variety of tree imaginable. (Courtesy of Kirk Farris.)

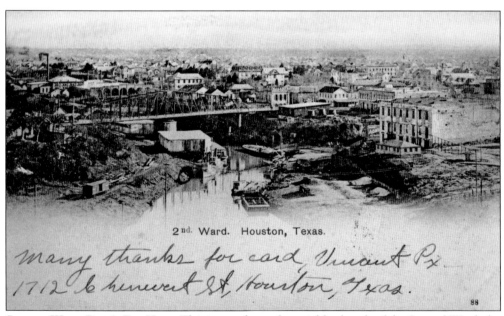

SECOND WARD BIRD'S-EYE VIEW. This image shows the neighborhoods of the Second Ward, the Fifth Ward, and Frost Town, on the north side of the bayou. The Willow Street iron truss swing bridge is visible. This bridge became the alignment of present-day San Jacinto Street concrete bridge. Notice the schooners, steam tugs, and barges that are tied to docks on both sides of the bayou. (Courtesy of Kirk Farris.)

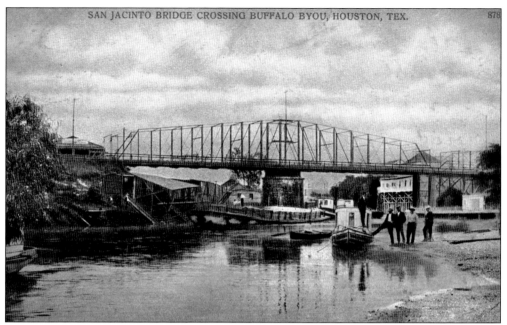

SAN JACINTO BRIDGE CROSSING BUFFALO BAYOU. This swing bridge built in the 1880s connected Second Ward to the industrial Fifth Ward and was called San Jacinto Street Bridge and Willow Street Bridge. This photograph shows an early steam tug and barge loaded with shell as well as a boat pivoted against the natural sandbar at the foot of Main Street. (Courtesy of the Heritage Society.)

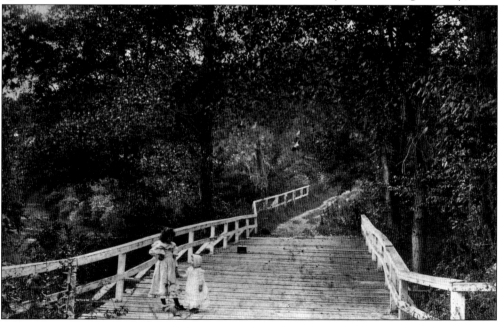

BEAUCHAMP SPRINGS. This wooden bridge crossed Beauchamp Springs, an active waterway on the south side of White Oak Bayou, west of present-day Houston Avenue. This bridge, although narrow, would have been wide enough for wagons drawn by horses or mules. The Victorian attire of the children on the bridge reminds one of a time when the pace of life was slower. (Courtesy of Kirk Farris.)

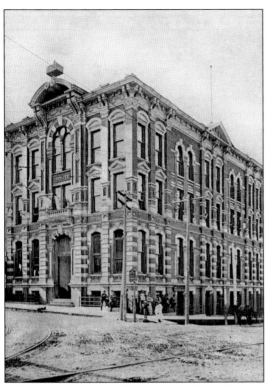

COTTON EXCHANGE BUILDING. In 1885, the Houston Cotton Exchange and Board of Trade completed construction of its three-story headquarters at Travis Street and Franklin Avenue. Eugene T. Heiner designed the building in a Victorian Renaissance Revival style. Notice the wonderful finishing touch of the bale of square cotton on the roof. (Courtesy of James Daniel Becker.)

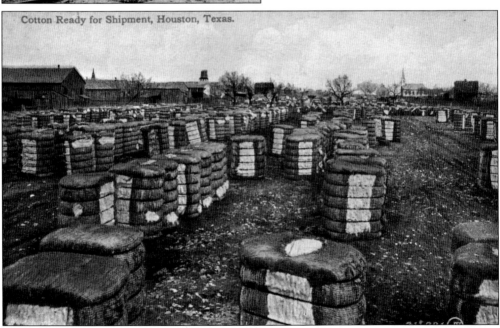

COTTON BALES READY FOR SHIPMENT. The cotton industry in Houston was booming for decades. Cotton was produced commercially in Texas from the days of the Austin Colony. Within a decade after the Civil War, Texas had become the leading cotton-producing state in the United States. Houston, because of Buffalo Bayou, was a link between the interior of Texas and the rest of the world. (Courtesy of Gail M. Miller.)

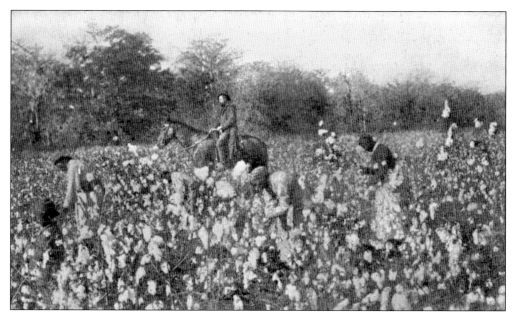

COTTON PICKING. There was employment to be found in the cotton fields. In 1860, cotton exports from Houston surpassed 100,000 bales. But although cotton dominated Texas agriculture, prices paid to farmers rarely covered costs. Landowners and tenant farmers struggled to make ends meet and were unable to diversify into crops that might have pulled them out of debt. (Courtesy of Gail M. Miller.)

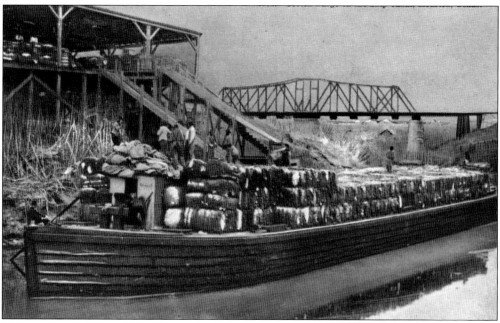

COTTON ON THE BARGE SHIP CHANNEL. This picture shows the Bayou Compress on the left with the International Great Northern Railway bridge in the background. This bridge would swing open to let ships pass and also accommodated horse-and-buggy traffic. The wooden platform used for loading cotton was an innovation that improved the work environment. (Courtesy of Gail M. Miller.)

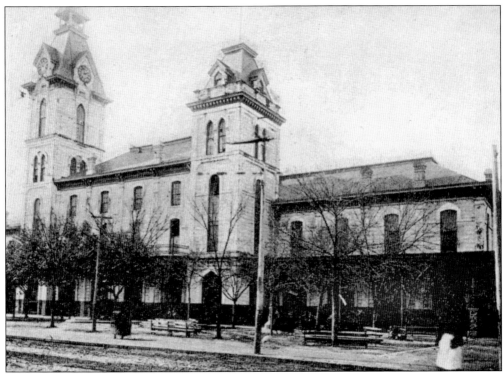

MARKET HOUSE IN MARKET SQUARE. Located on the block bound by Congress Avenue and Travis, Milam, and Preston Streets, the Market House was intended as the future Halls of Congress, but the capital of the Republic of Texas did not remain in Houston. Instead, this area became an open market. The city hall and Market House were built in 1840. (Courtesy of Gail M. Miller.)

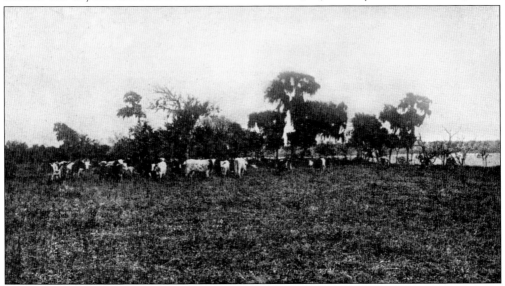

CATTLE. From 1866 until 1900, cowboys rounded up and drove longhorn cattle up the Chisholm Trail to railheads in Abilene and Dodge City. Because English breeds of cattle have plumper beef and longhorn meat is leaner, the breed was largely ignored as a meat source until the early 1900s. The beef cattle in this picture are grazing on a private range. (Courtesy of Gail M. Miller.)

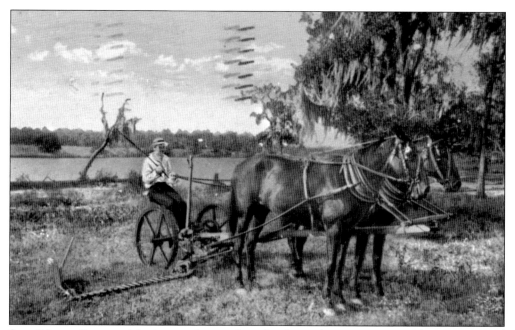

SALT MARSH FARMER. Mowing on the marsh with a horse-drawn mowing machine was a good alternative to using scythes for harvesting. This hay is made from grasses that grow in coastal marshes, valuable mulch that does not pack down as much as ordinary hay. Special shoes were used on these horses called "bog" shoes that would enable them to maneuver through swampy areas. (Courtesy of Gail M. Miller.)

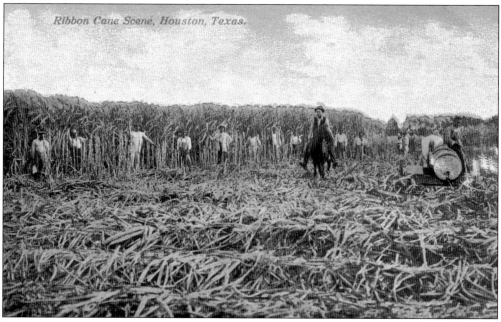

RIBBON CANE HARVEST SCENE. Subsistence crops such as corn, field peas, and ribbon cane were grown near Houston and made some landowners quite wealthy. It was a labor-intensive industry. Houston and South Texas became known for their sugar production, and one of the largest sugar plantations of the day was Arcola, owned by the House family. (Courtesy of Gail M. Miller.)

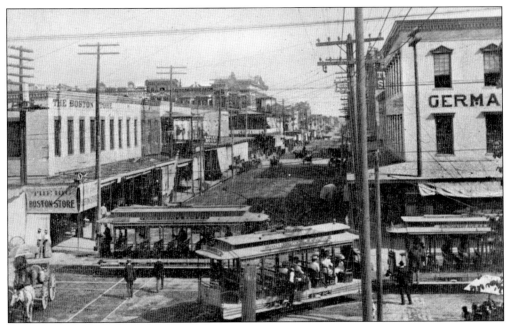

CONGRESS AVENUE. The streetcar was a visible part of the urban scene, and during the age of electric traction, no city seemed complete without it. Population growth followed the car lines. The Boston Store on the left was located at 303 and 36 Main Street. It specialized in ladies' apparel, which included hats and "ready to wear" clothing, and an infants' and children's section. (Courtesy of Robert P. Cochran.)

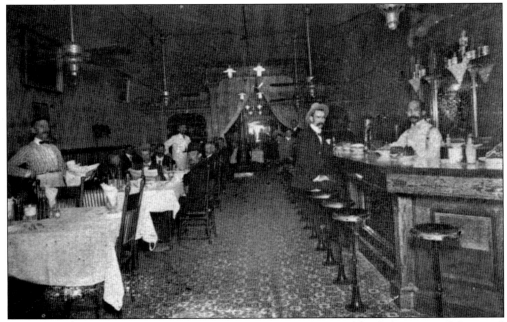

LITTLE GEM RESTAURANT. At the Little Gem Restaurant, one could either get a quick beer and bowl of chili at the counter or sit down to a fine steak dinner. This restaurant's food must have catered to the male palate. In the late 1800s, downtown Houston had restaurants, saloons, and even a gambling establishment, the Turf Club. (Courtesy of Robert P. Cochran.)

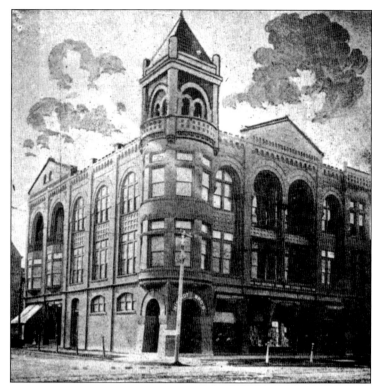

HOUSTON LIGHT GUARD ARMORY. Designed in 1891 by George Dickey, this building was located at the corner of Texas Avenue and Fannin Street. The Houston Light Guard held precision drill practices, dances, and meetings in this building. For weeks prior to a competition, the men slept in the armory. The Mistrot brothers were the proprietors of the Armory Department Store located on the bottom floor. (Courtesy of James Daniel Becker.)

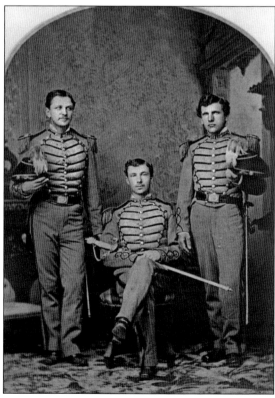

OFFICERS OF THE HOUSTON LIGHT GUARD. They were Houston's crack military company and assisted in parades and other public functions. The company included in its membership the finest and most cultured young men in the city, who were so thoroughly drilled and versed in the arms manual that they won the highest honors. Pictured here are William Childress (left), Jonas S. Rice (center), and John A. Kirlicks. (Courtesy of James Daniel Becker.)

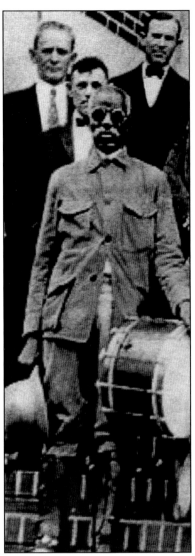

CAPT. JOHN SESSUMS. Sessums was the first African American member of the Houston Light Guard and the only drummer for 52 years. He was born in 1842, joined the Light Guard in 1872, and was the drummer through all of their winning competitions. In 1886, he won a gold medal in Philadelphia, where he was the only black drummer among more than 500 participants. (Courtesy of James Daniel Becker.)

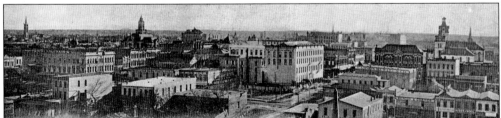

HOUSTON PANORAMA. Houston included, from left to right, (first row) Houston Cornice Works (813 Commerce Avenue), Carlton Company (815 Commerce Avenue), B. A. Riesner Carriages and Wagons (817 Commerce Avenue), and Bering and Cortes (819 Commerce Avenue); (second row) T. H. Thompson and Company Fruit and Produce and Carson, Sewall, and Company; (third row) J. W. Heitmann and Company, the New Hutchins House Hotel, and the Cotton Exchange; (fourth row) the spire of Annunciation Church, the spire of Harris County Courthouse, Kiam's, and Sweeney and Combs. (Courtesy of Robert P. Cochran.)

FANNIE BURKE. Fannie was the daughter of Mayor A. J. Burke. Born in 1856, she attended the Houston Academy and was educated in Connecticut during the Civil War. She married Allen Blake, a Houston Light Guard member, in 1887, but within a year, she died, along with her baby. Fannie and the baby are buried in the Burke plot at Glenwood Cemetery. (Courtesy of James Daniel Becker.)

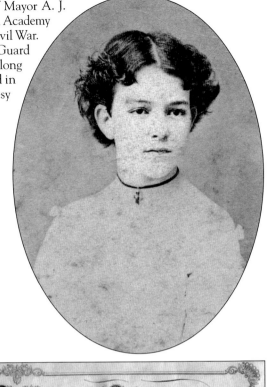

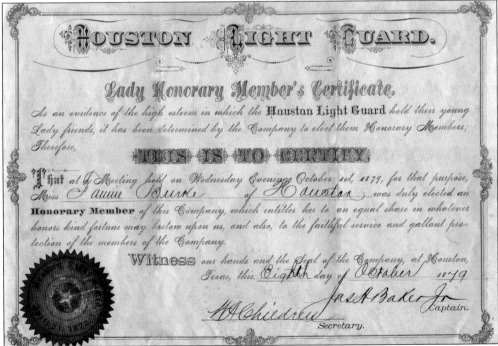

HOUSTON LIGHT GUARD HONORARY MEMBERSHIP. The Light Guard Armory was the scene of many dances and gala events. The men would occasionally select their "best" girls to be honorary members. Fannie Burke was one such darling girl. In 1879, James A. Baker Jr. was captain and William H. Childress was secretary of the Houston Light Guard. (Courtesy of Robert P. Cochran.)

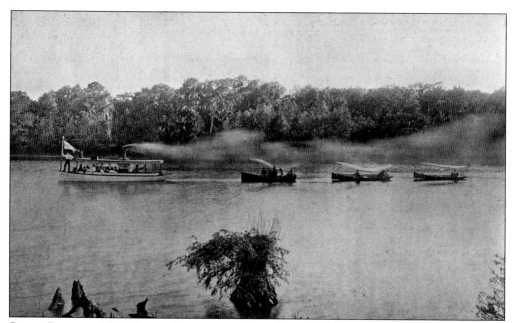

STEAM LAUNCH. This picture shows a steam launch on Buffalo Bayou. Steam propulsion and railroads developed separately, but it was not until railroads adopted the technology of steam that they began to flourish. This picture shows the speed with which the steam launch could sail. By the 1870s, railroads had begun to supplant steamboats as the major transporter of both goods and passengers. (Courtesy of Gail M. Miller.)

DELIGHTFUL BUFFALO BAYOU. A visitor to Houston in 1874 observed "the bayou which leads to Galveston, and is one of the main commercial highways between the two cities, is overhung by lofty and graceful magnolias; and in the season of their blossoming, one may sail for miles along the channel with the heavy passionate fragrance of the queen flower drifting around him." (Courtesy of Gail M. Miller.)

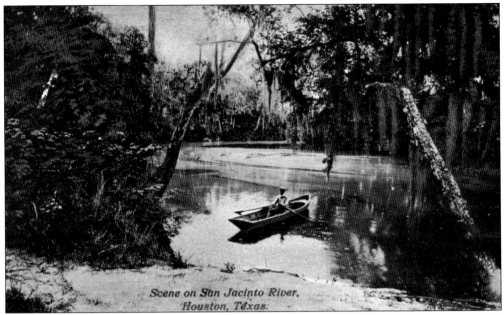

SCENE ON SAN JACINTO RIVER. On a lazy early summer day, it was nice sailing on the river, where the fragrance of magnolias would fill the air. A variety of rare species lived along the river, including wood storks, white ibises, and Swanson's warbler. The forests had a diversity of trees, including the American hornbeam, river birch, black tupelo, and southern magnolia, to name a few. (Courtesy of Gail M. Miller.)

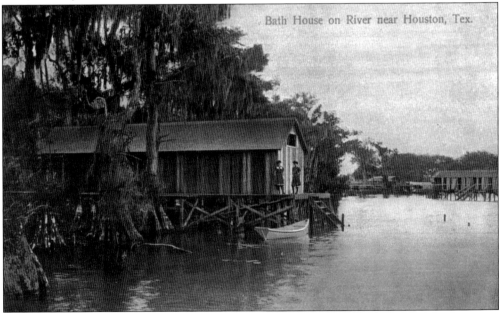

BATHHOUSE ON THE RIVER. A bathhouse much like the modern-day locker rooms had separate facilities for men and women. The interior of this building had locking stalls where swimmers would be able to change their clothing. There was not running water, but privacy was abundant. Swimming attire was quite modest, as the women wore bathing dresses. (Courtesy of Gail M. Miller.)

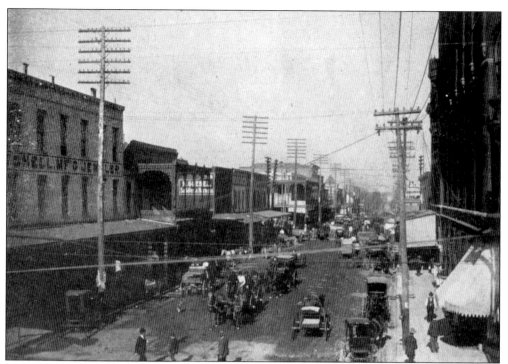

Milam Street. Milam Street, one of the streets that bordered Market Square, had a great diversity of businesses in operation. There were jewelry stores, produce wholesalers, lawyers, doctors, barbers, and restaurants. Here one can see the back side of Desel and Boettcher Company on the left. (Courtesy of Robert P. Cochran.)

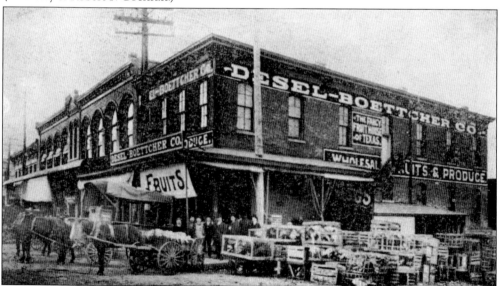

Desel and Boettcher Company. On the corner of Congress Avenue and Main Street, Desel and Boettcher Company was one of the largest and most successful wholesale fruit and produce houses in the Southwest. They were also the largest shippers of Texas eggs to Northern markets. They received daily carloads of California fruits such as grapes, peaches, plums, and apples. (Courtesy of Robert P. Cochran.)

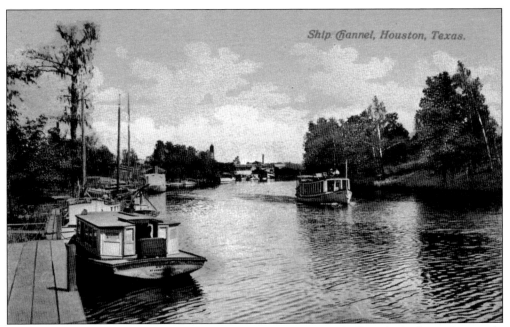

SHALLOW-DRAFT CHANNEL. This postcard shows traffic on a shallow-draft channel. In early Houston, the shallow-draft channel was used to transport cotton and other goods to the foot of Main Street. In 1870, Houston was designated as a port of entry by the United States and plans were made to deepen the channel, preparing the way for the eventual deep ship channel. (Courtesy of Gail M. Miller.)

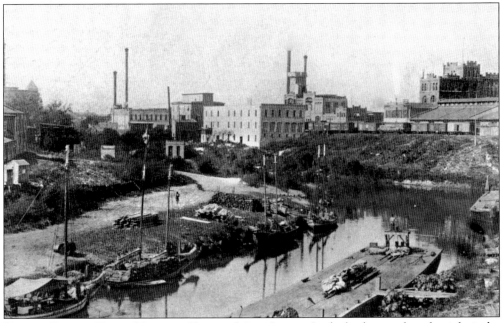

VIEW OF BUFFALO BAYOU NEAR THE FOOT OF MAIN STREET. In the background on the right is the James Bute Company warehouse with the Anheuser Busch Brewing Company behind it. There is a barge on the right side of the picture, and on the left are common cargo sailing vessels that made the trip from Houston to Galveston every day. (Courtesy of Robert P. Cochran.)

MAJ. JOHN F. DICKSON. Major Dickson was president and treasurer of the Dickson Car Wheel Factory. He was a big supporter of Houston and a founding member of many organizations, including the Thalian Club. He was an innovator in the field of railway equipment and had one of the largest factories in Texas. (Courtesy of Robert P. Cochran.)

SOUTHERN PACIFIC. Major Dickson anticipated the impact a rail system would have on Houston. The City Railroad was brought into existence on April 8, 1868, and track-laying began a short time later. Within 10 years, several miles of track stretched along Preston Avenue from Market Square (at Travis Street) to Allen's Station. Later, tracks were laid on Dowling Street and Congress Avenue to complete a circuit to Market Square. (Courtesy of Robert P. Cochran.)

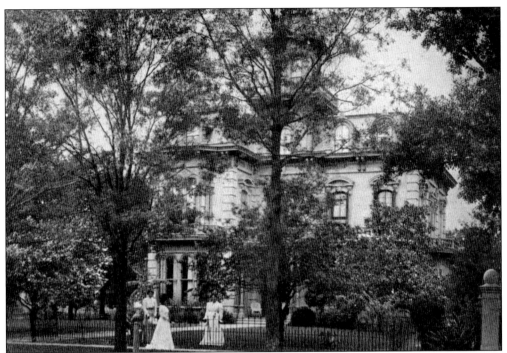

DICKSON HOME. This stately home was located at 1216 Main Street and was purchased by Major Dickson at the dawn of the 20th century from James Masterson. Unlike today, Main Street in the late 1800s was lined with palatial residences and huge gardens. It was not unusual for one residence to occupy the entire block. (Courtesy of Robert P. Cochran.)

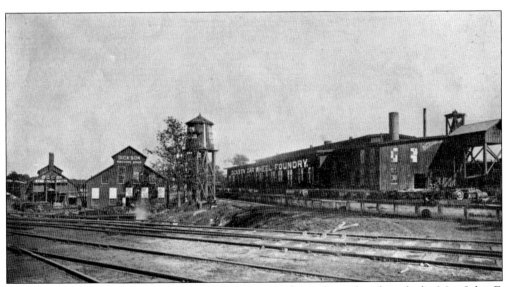

THE DICKSON CAR WHEEL FACTORY. This factory built on the railroad tracks by Maj. John F. Dickson manufactured railroad equipment. The maintenance and repair of cars and wheels was quite efficient. Its car wheel works, at the start of the 20th century, had a capacity of 50,000 car wheels annually. On the left are the general foundry, machine shop, and car wheel foundry, where they made repair work a specialty. (Courtesy of Robert P. Cochran.)

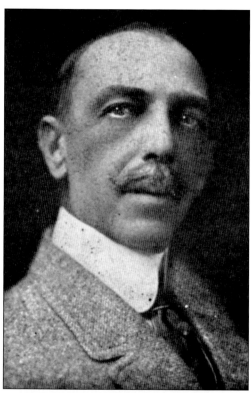

ABE LEVY. The Levy Brothers company was started by Abraham M. Levy, who was the son of M. H. and Adelena J. Levy, who emigrated from Prussia. Abe was born in Houston, Texas, on September 23, 1859. He attended private schools in Houston and worked as a clerk for William Foley before founding his own business in 1887 with his brother Leo. (Courtesy of Robert P. Cochran.)

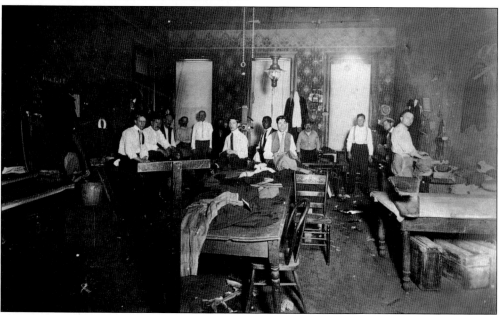

INTERIOR OF A CLOTHIER WORKROOM. This image shows a Victorian clothing workroom. There are sewing machines, yet notice the flat iron on the stove. It has a cloth wrapped around the handle to prevent burns. The only water is in a bucket placed in front of the mirror. The Levy Brothers may have had a clothier workroom in their establishment. (Courtesy of Dawn Fudge and the Last Concert Café.)

LEVY BROTHERS BUILDING. The Levy Brothers mercantile business occupied this four-story building. They had a workroom for tailors and a basement where every inch of space was filled with goods imported from all over the world. By 1897, the company employed 400 people and was considered the largest mercantile establishment in the South. (Courtesy of Robert P. Cochran.)

MERCHANTS CONVENTION DOWNTOWN HOUSTON. William and Louise Bingle Swilley are among the merchants in this photograph. In the 1900 city directory, he is listed as having a grocery and meat market at 2218 German Avenue and a land office at 210½ Fannin Street. Merchants formed alliances to gain protection against greedy wholesalers or to share innovations in product lines. (Courtesy of Becky Brezik.)

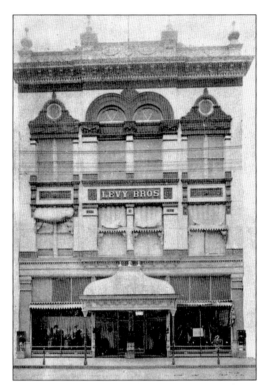

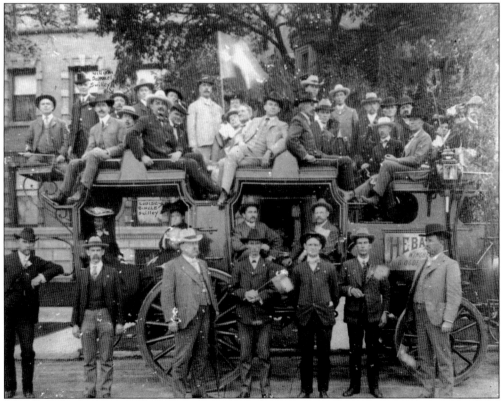

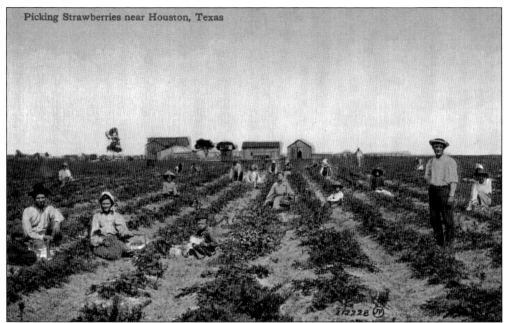

PICKING STRAWBERRIES. Strawberries were shipped to market from Houston on the tracks of the Galveston, Houston, and Henderson Railroad. They were easy to grow near Houston, and Burke's Almanac instructed, "Prepare the land well by deep plowing, lays the rows off three feet wide, plant one foot in the row, cultivate well, cut off runners, mulch well with 'straw or hay' just before the berries set and you will not fail." (Courtesy of Gail M. Miller.)

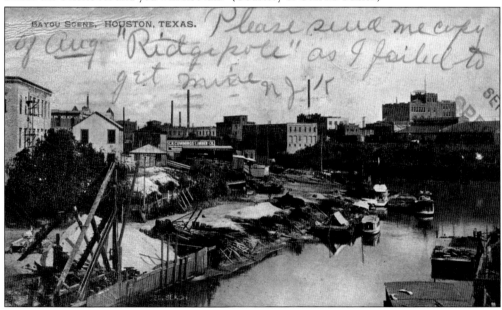

VIEW FROM SAN JACINTO BRIDGE. A very successful business, the C. R. Cummings warehouse can be seen in this picture. This location near the San Jacinto bridge was superb as Charles R. Cummings and his brother, Jesse, ran the largest sawmill in Texas. Lumber would be loaded on barges and sent down Buffalo Bayou to destinations as far south as Mexico and beyond. (Courtesy of Gail M. Miller.)

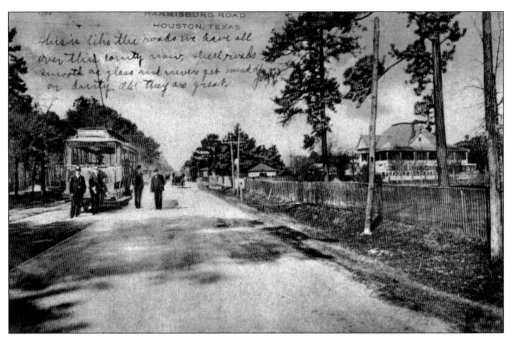

HARRISBURG ROAD, HOUSTON, TEXAS. This is a great example of the effect of oyster paved roads on the citizens of Houston. Notice the handwritten note on this postcard: "This is like the roads we have all over this county now, shell roads, smooth as glass and never get muddy, or dirty. ah!, they are great." As early as 1860, there were wooden sidewalks in downtown Houston. (Courtesy of Gail M. Miller.)

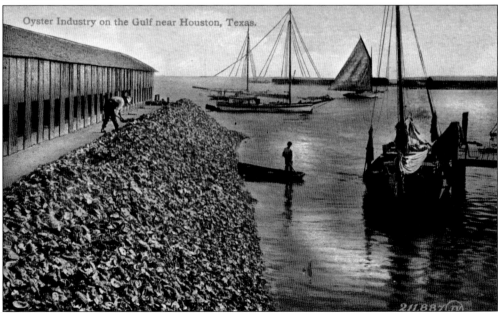

OYSTER INDUSTRY. Oysters were a popular food in Houston and consumed daily in restaurants like the Little Gem. The first bridge from Galveston Island to the mainland was completed in 1859, and this made shipment of all types of seafood easier and faster to the Houston market. Oyster shell was used as a surface for the first paved streets in Houston. (Courtesy of Gail M. Miller.)

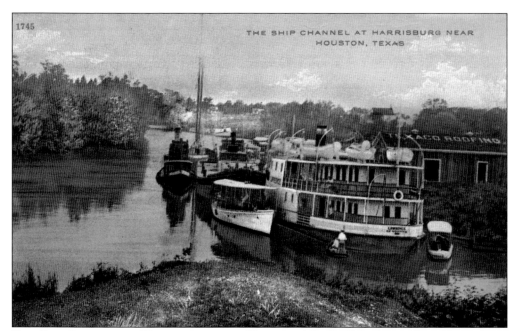

THE SHIP CHANNEL AT HARRISBURG NEAR HOUSTON. The Buffalo Bayou Ship Channel was completed to Clinton, eight miles below Houston, by April 1876, from which point the Texas Transportation Company had a railroad to Houston. Steamers drawing 12 feet of water were able to reach Clinton, averaging 50 carloads of freight each trip. (Courtesy of Gail M. Miller.)

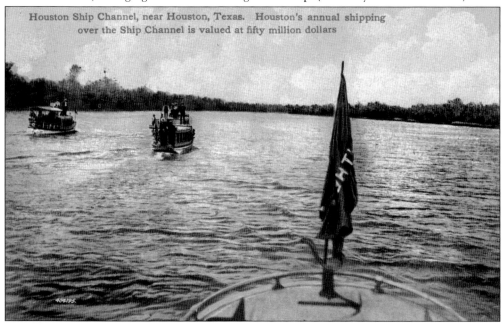

THE HOUSTON SHIP CHANNEL, NEAR HOUSTON. Commerce in Houston would take on a whole new meaning when the Buffalo Bayou was deep enough to make deliveries of goods all the way to Main Street merchants. By 1876, there were only about four miles of dredging and widening to be done to complete this journey, and Houston would easily receive goods from all over the world. (Courtesy of Gail M. Miller.)

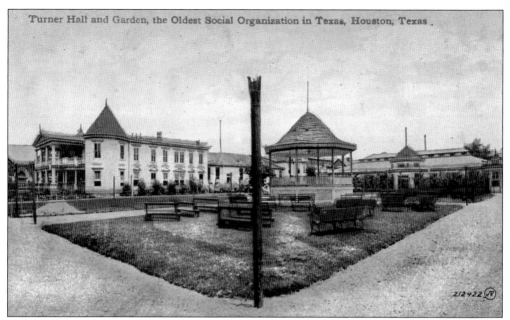

TURNER HALL AND GARDEN. Political refugees from Germany, the Turnverein believed in gymnastics and physical education in schools. In 1854, the "Turners" arrived in Houston, established schools, provided dramatic and musical entertainment for the public, and cared for the sick and needy. Turners founded several of the first volunteer fire departments, and they hosted excellent dances, parties, and Fourth of July celebrations. (Courtesy of Gail M. Miller.)

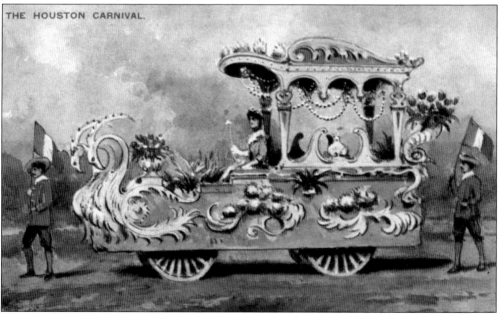

HOUSTON CARNIVAL. Another form of amusement in Houston was the Houston Carnival, or Notsuoh (Houston spelled backwards). This was a citywide event, and there would always be a King Nottoc (cotton spelled backwards). The first king was Augustus C. Allen, a founder of Houston, and after the dawn of the 20th century, Jesse Jones held reign. (Courtesy of the Heritage Society.)

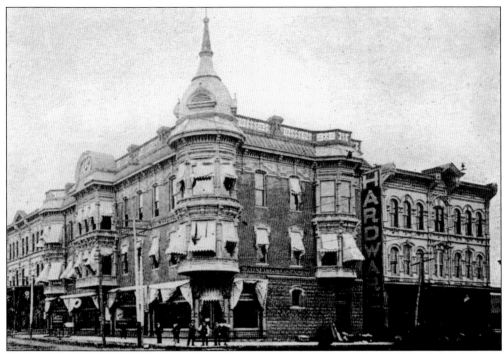

GIBBS BUILDING. In 1891, Col. C. C. Gibbs was a land commissioner for the Southern Pacific Railroad. The Gibbs Building was located on the northwest corner of Fannin Street and Franklin Avenue in 1893. This two-story structure was the location of Wells Fargo and Company, which occupied the ground floor, and the law firm of Baker, Botts, and Baker, which had space on the upper floor. (Courtesy of Robert P. Cochran.)

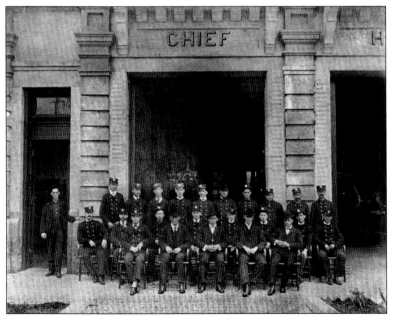

HOUSTON FIRE DEPARTMENT. The fire department continued to grow right along with the rest of Houston. This picture shows a much larger station than No. 5, with two bays for the equipment. At this time, the volunteer fire units, like Fire Protection No. 1, were a thing of the past and these men were paid employees. (Courtesy of Robert P. Cochran.)

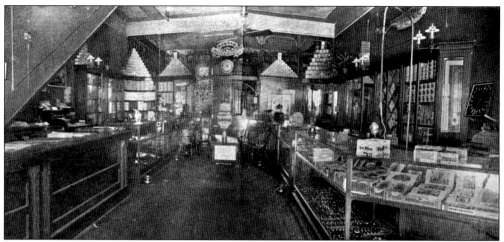

INTERIOR OF A CIGAR STORE. At the close of the 19th century, cigar stores were beginning to modernize. The introduction of the chain store idea helped cigar dealers to become much more successful. Cigar stores had all-glass showcases, humidifying devices, better sanitation, and beautiful points of display to entice the customer. (Courtesy of Robert P. Cochran.)

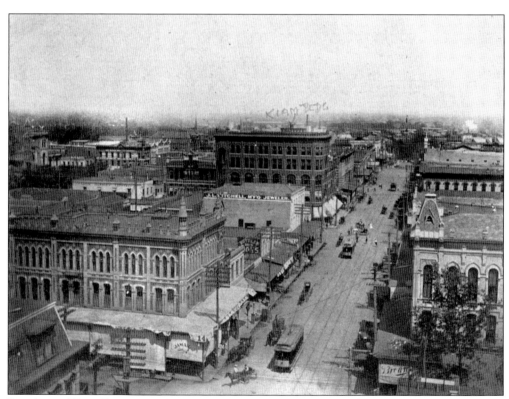

BIRD'S-EYE VIEW LOOKING NORTH FROM THE BINZ BUILDING. This is a good picture of the Kiam, Mitchell, and Jamail businesses. Here electric trolleys compete for street territory with both pedestrians and horses. The Kiam Building is located at 314–320 Main Street. This picture was taken in the Binz Building on the corner of Texas and Main Streets in 1898. (Courtesy of Robert P. Cochran.)

OLD COUNTRY HOME NEAR HOUSTON. In the late 1800s, people slowly moved from the country and built large homes along Main Street. The second generation, children of the early settlers, usually was the first to move into town. Many of the wealthier merchant farmers also kept their country properties. Notice the buggy parked on the right, just waiting to be saddled to a horse and driven into town. (Courtesy of Gail M. Miller.)

SCHOOLCHILDREN. A mixture of city and country children often attended the same school. Here is an elementary class at the dawn of the 20th century. Mary Louise Howze is in the second row with a plaid dress and long black hair. Notice the barefooted boy in the first row. (Courtesy of SallyKate Marshall Weems.)

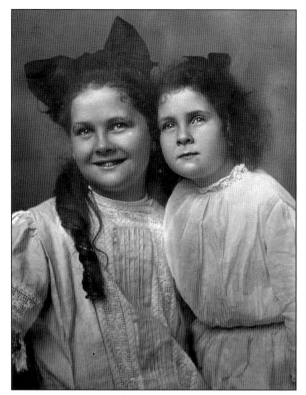

RUTH AND MARY LOUISE HOWZE. Ruth (left) and Mary Louise are examples of third-generation Houstonians. They were the granddaughters of Thomas W. House, who came to Houston as a baker and was instrumental in establishing the framework for this great city. They too would carry on the family tradition of fine Texas values and work ethic. (Courtesy of SallyKate Marshall Weems.)

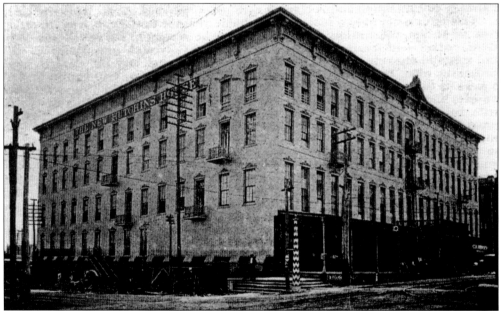

THE NEW HUTCHINS HOTEL. First built in 1861 by William J. Hutchins, this was the largest hotel in the state of Texas. Hutchins was a railroad developer and mayor of Houston. He died in 1884, but his hotel remained and was the site of many conventions. Henry Bradley Sanborn, the father of barbed wire in Texas, purchased the Hutchins House in Houston in 1892 and made it a first-class hotel. (Courtesy of Robert P. Cochran.)

Elizabeth Cady Stanton. Elizabeth Cady Stanton, one of the three most prominent suffragist leaders, traveled and lectured on the rights of women and unborn children. In 1895, she sent this letter to Matilda Cushing as an apology for not being able to reach Houston because of the great storm. She was scheduled to speak in Houston and stay at the Cushing estate, called Bohemia. (Courtesy of James Daniel Becker.)

The Carnegie Library. Chartered in August 1900, the Houston Lyceum and Carnegie Library Association, with the help of the newly formed City Federation of Women's Clubs, raised funds to purchase an appropriate site. The city's first central public library opened in 1904 at the site of the former residence of Thomas M. Bagby, an early pioneer and builder of Houston. (Courtesy of Robert P. Cochran.)

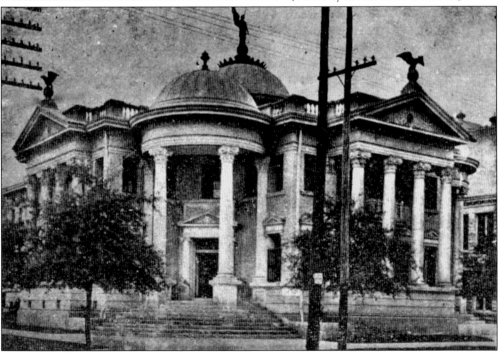

BESSIE LEE BRANUM. Bessie Lee Branum, a native Houstonian, poses in her graduation dress in early 1900. She enjoyed the success available to young women at that time. She was assistant editor of the *Aegis*, the school paper, wrote the music and lyrics to the class song, and was awarded a college scholarship. (Courtesy of Patti Heininger.)

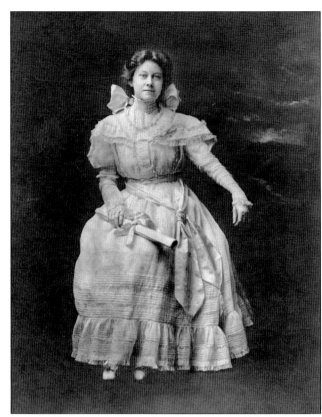

BOATS ON THE BAYOU. Buffalo Bayou was a wonderful source of amusement for young Houstonians. Here an unidentified young couple ventures close to the bank to get their photograph taken while rowing down the bayou. She is wearing a fancy traveling hat, common to the time period. The grandchildren of Houston settlers had a lot of opportunity and bright futures. (Courtesy of Robert P. Cochran.)

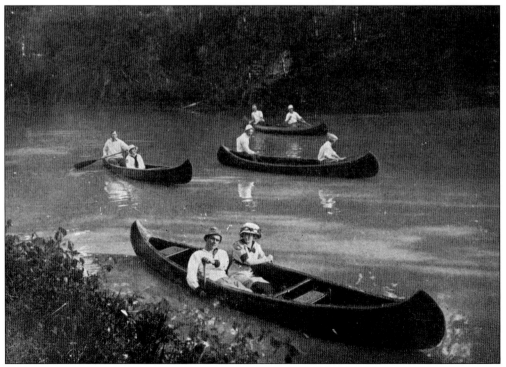

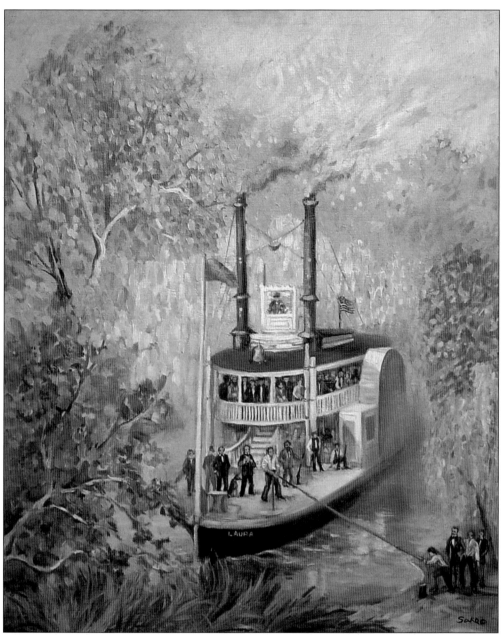

AS THE RAILS MEET THE SEA. Judith-Ann Saks painted this lovely watercolor of Allen's Landing. This image shows Houston around the year 1870. The *St. Clair* is typical of the large stern-paddle steamers that traveled rivers like the Mississippi and along the coast carrying passengers and cargo. Cotton, then king of crops, is being loaded after being brought from inland on mule-drawn wagons, which stand nearby. The barrels contain resin or molasses. The locomotive on the trestle over White Oak Bayou at its junction with Buffalo Bayou is the "General Sherman," the first engine used in Texas. As the rail connected with the waterway, Houston rapidly became a busy city. Ziegler's warehouse, one of the first warehouses to store goods for import or export, is painted with an American and a Texas flag, symbolic because Texas was by then part of the United States. (Copyright © Judith-Ann Saks, all rights reserved.)

Four
SPARK INTO THE FUTURE

FRANK ALDERETTE. Relaxing in his room at 1509 Sterret Street in Houston, Alderette is surrounded by the memorabilia of trips taken north. A banner from Lake Nokomis, Wisconsin, and a pendant for Heath and Milligan Best Prepared Paint adorn the room. Notice the clothing hung on the wall, suggesting a lack of closet space, or perhaps hung in preparation for a special evening in Houston. (Courtesy of Dawn Fudge and the Last Concert Café.)

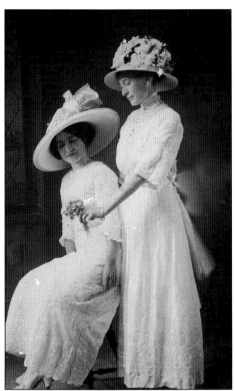

HELENA AND LUISA ALDERETTE. As the 20th century dawned, the silhouette of ladies' clothing began to change as skirts slimmed and hat brims broadened. Mother Luisa and daughter Helena admire a corsage while dressed in high-collar lace dresses and touring hats lavishly bedecked with silk, netting, lace, and flowers—the perfect attire with which to promenade. (Courtesy of Dawn Fudge and the Last Concert Café.)

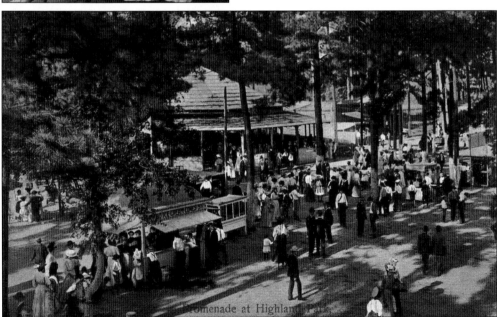

PROMENADE AT HIGHLAND PARK. A favorite activity in Houston at the turn of the 20th century was a visit to Highland Park. Women dressed in touring hats and flowing dresses stroll through this amusement park. Highland Park had a dance pavilion, boat rides, wooden amusement rides, and a special attraction called "shoot-the-chute," where a person would slide down a steep grade into the water. (Courtesy of Gail M. Miller.)

Hispanic Houstonians. The Hispanic population in Houston by the end of the 19th century was thought to be around 500 individuals. In this picture, two members of the Aldrette-Lopez family pose in front of their home, which is today the Last Concert Café in Houston. (Courtesy of Dawn Fudge and the Last Concert Café.)

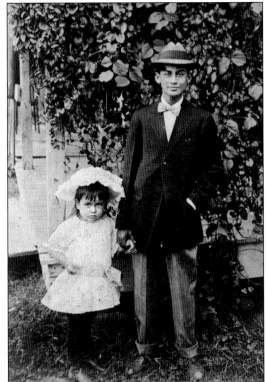

Target Shooting. Farther from Allen's Landing, Houston remained a frontier town. Outside of the city limits, on the west side of town, the prairie stretched on for many miles. In this picture, a friend of the Aldrette-Lopez family poses with tented rifles and gun drawn for the photographer. (Courtesy of Dawn Fudge and the Last Concert Café.)

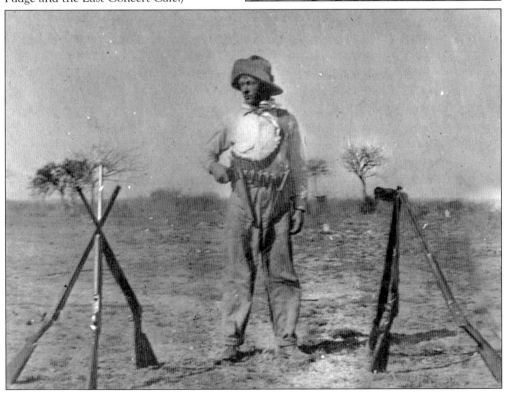

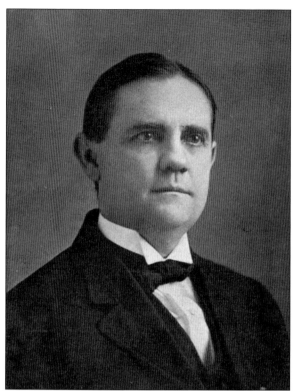

MAYOR SAMUEL BRASHEAR. Mayor Brashear appointed Houston's first park committee to oversee the establishment of a city park that was developed on land purchased from the Noble estate in 1899. Appropriately named Sam Houston Park, it was located in downtown Houston. The 20-acre spot was landscaped into a Victorian-style village, with footpaths leading across a bridge that traversed a small stream. (Courtesy of the Heritage Society.)

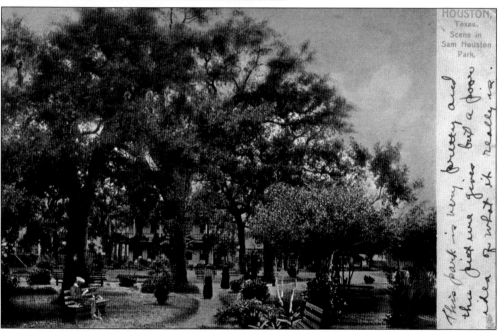

SAM HOUSTON PARK. The two-story house in the background is the Kellum-Noble house. This house, in Sam Houston Park today, stands on the exact location where it was built by Nathaniel Kellum in 1847. This house was at one time the location of a school and a small zoo. Nathaniel Kellum had a brickyard and a tannery on this property. (Courtesy of the Heritage Society.)

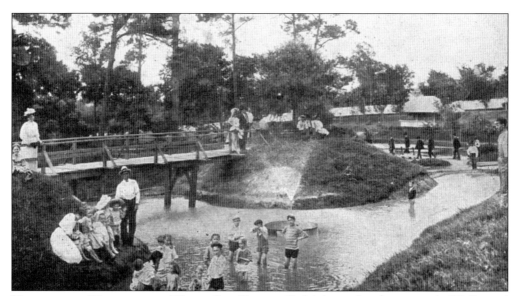

HOUSTONIANS WADING IN THE WATER. Sam Houston Park is located at the west end of Dallas and Lamar Avenues at Bagby Street. As seen in this postcard, it was reported that as many as 4,000 visitors came to the park on days when the weather was pleasant. All Houstonians, from children to businessmen, took time out to enjoy the wading pond. (Courtesy of Gail M. Miller.)

THE CROWDS AT SAM HOUSTON PARK. The *Houston Daily Telegraph* on Sunday, February 23, 1879, read, "Suburban Sunday Sports—At the city park . . . about dusk . . . the young folks danced to the inspiring tones of an open air concert band . . . those of maturer years sitting around tables, played cards, joked and quaffed the frothy beer. A sheltered bandstand was built in the center of the park, and elaborate playground equipment and a small cement wading pool were provided for children." (Courtesy of Gail M. Miller.)

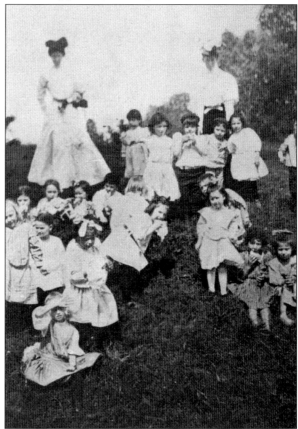

EUGENE PILLOT. Eugene Pillot was from France. In 1868, he moved his family to Houston and enjoyed a very successful business career. He was a member of the Board of Aldermen, treasurer of Harris County, and a member of the Board of Public Works. In 1879, he owned Pillot's Opera House and brought to Houston performers such as Lily Langtree, Maurice Barrymore, and Edwin Booth. (Courtesy of SallyKate Marshall Weems.)

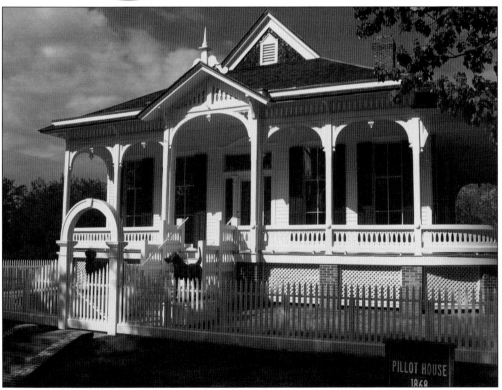

THE PILLOT HOME. Built in 1868 at the corner of McKinney Avenue and Chenevert Street, this home was occupied by the Pillot family for 96 years. In 1965, the family donated the house to Sam Houston Park, where it can be seen today. The mid-Victorian structure features significant innovations, including its kitchen, which is believed to have been one of the first attached kitchens in Houston. (Courtesy of the Heritage Society.)

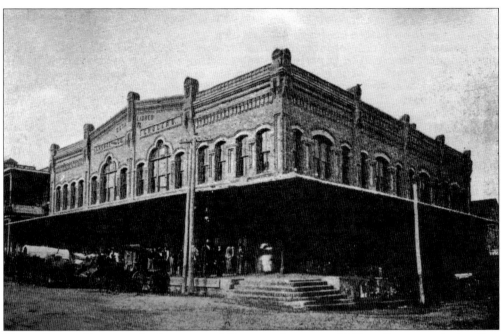

HENKE PILLOT GROCERY. At the corner of Congress Avenue and Milam Street stood a bustling center of daily life. Founder Henry Henke promoted his bookkeeper, Camille Gabriel Pillot, to partner, and the business took the name Henke and Pillot. It is known today by the name Kroger. (Courtesy of Robert P. Cochran.)

INTERIOR, HENKE PILLOT GROCERY. An 1898 advertisement read, "Be wise and come to us for your Groceries. We supply the best of everything in the food line. Our stock is gathered from the four quarters of the earth. Every country and climate contributes to our grand food exhibition. Seek what you want here and you'll find it. In a first choice for quality and lowness of price." (Courtesy of Robert P. Cochran.)

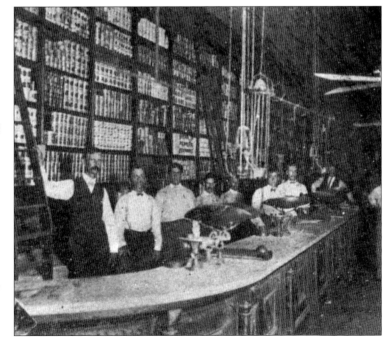

LUCRETIA JENNETTE FUQUA (1856–1944). Lucretia was the daughter of Joseph Watkins Fuqua and Charlotte Lydia Valentine. She married Evander McKeever Perkins. Her legacy to Houston can still be seen today as it was later generations of the Perkins family that donated Old Place to the Heritage Society for Sam Houston Park. Now generations to follow can experience, firsthand, the hardships encountered in early Houston. (Courtesy of Jennette Jackson Hunnicutt.)

OLD PLACE IN SAM HOUSTON PARK. This cabin was moved from the west bank of Clear Creek in 1973 and is thought to be the oldest remaining structure in Harris County. This structure was built in about 1823. Roughly hewn cedar logs form the frame, which was incorporated by later owners into a much larger house, once known as the Joseph Davis Plantation house. (Courtesy of the Heritage Society.)

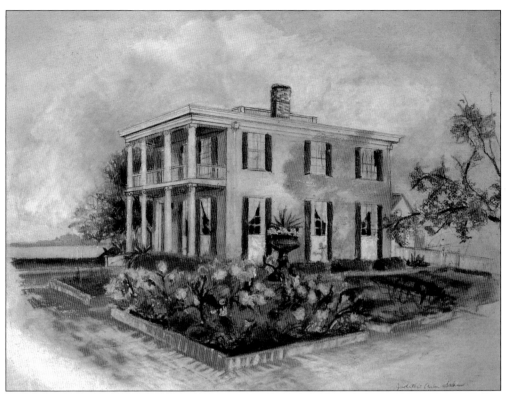

NICHOLS RICE CHERRY HOUSE. This Greek Revival house was built about 1850 by New Yorker Ebenezer B. Nichols, then owned by William Marsh Rice, the benefactor of Rice University, and finally bought by Emma Richardson Cherry. In 1897, the house was saved from demolition by Cherry and moved from its downtown site. In 1959, it became the first house to be moved into Sam Houston Park. (Copyright © Judith-Ann Saks, all rights reserved.)

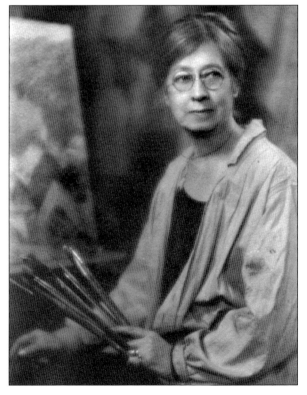

EMMA RICHARDSON CHERRY. One of the earliest professional female artists in Houston, Cherry worked in oils, watercolors, pastels, pencil, and charcoal, though at least one critic referred to her use of "modern" laws of color. She was known for her paintings of flowers and, in 1937, did a study of oleanders to be presented to Pres. Franklin Roosevelt during his visit to Galveston. (Courtesy of the Heritage Society.)

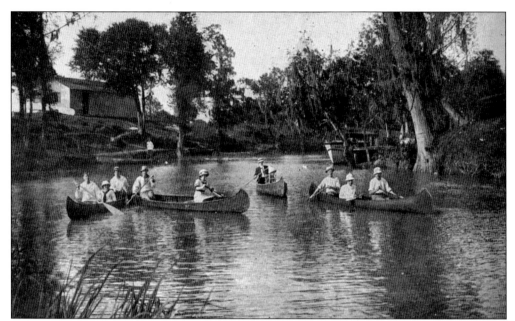

CANOE CLUB ON SAN JACINTO RIVER. In 1866, the Royal Canoe Club was formed in England, and the Prince of Wales became commodore. In early-20th-century Houston, canoe clubs and activities, as depicted in the photograph, took place on both Buffalo Bayou and on the San Jacinto River. (Courtesy of Robert P. Cochran.)

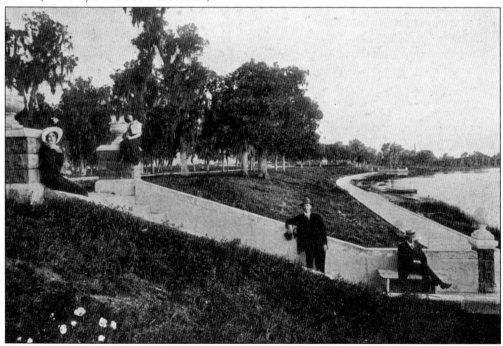

SAN JACINTO PARK. In 1899, the State of Texas bought the land near where the Texas army and the Mexican army camped during the Battle of San Jacinto. By 1900, a total of 336 acres of land was designated for a park to commemorate the battle, and this area is still being used recreationally by Houstonians. (Courtesy of Robert P. Cochran.)

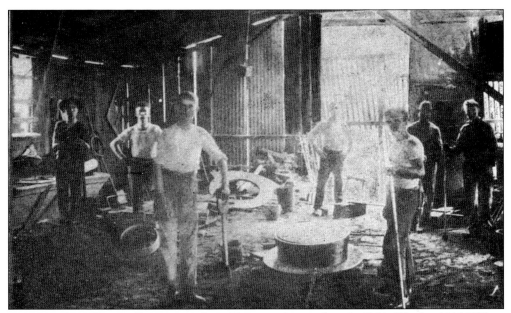

HOUSTON IRON WORKS, BRASS, AND IRON FOUNDRY. Located in the Fifth Ward at 1008 Willow Street, this company manufactured oil well supplies, iron stairways, and fire escapes. They also produced bank safes, iron shutters, a variety of iron and brass castings, iron fonts, jails and cells, cemetery railing and verandas, and floral cast iron ornaments. They were the top producers of iron and brass products in the Houston area. (Courtesy of Robert P. Cochran.)

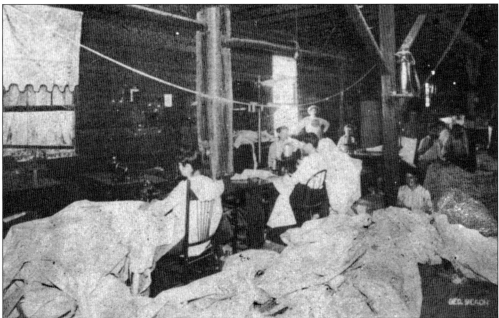

KATTMAN AND KNEELAND TENT COMPANY. Fred Kneeland and Agnes Kattman employed a large force of skilled and high-priced labor. Located at 1212 Franklin Avenue, this company manufactured tents, tarpaulins, and awnings. They made a specialty of covered wagons, and the name of Kattman and Kneeland can be seen stamped on prairie schooners on the open plains. (Courtesy of Robert P. Cochran.)

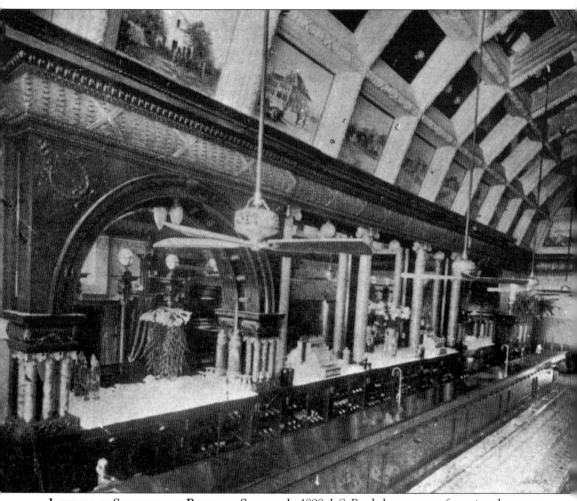

INTERIOR OF SCHARCK AND BOTTLERS SALOON. In 1898, J. S. Purdy began manufacturing showcases and fixtures. The Houston Showcase and Manufacturing Company was located at Washington Street and Houston Heights. This saloon was outfitted with the best and most recent fixtures available, including low-hanging ceiling fans to cut the Houston summer heat. (Courtesy of Robert P. Cochran.)

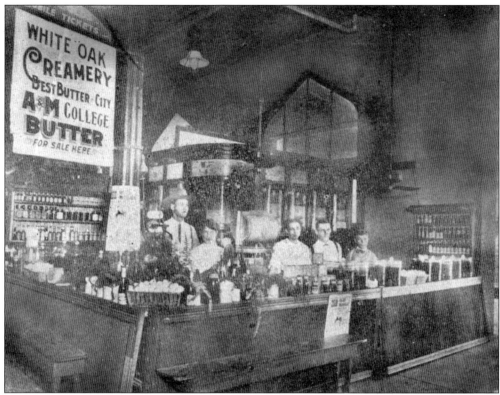

MARKET HOUSE. Market House vendors would serve customers from behind the counter. The stalls were fully staffed, and shopping was made much more convenient. There was often a market master who supervised the "order and decorum" of the market and disputes between buyer and sellers. Vendors carried a variety of products from across the state. The Market House became the hub of social life in Houston. (Courtesy of Robert P. Cochran.)

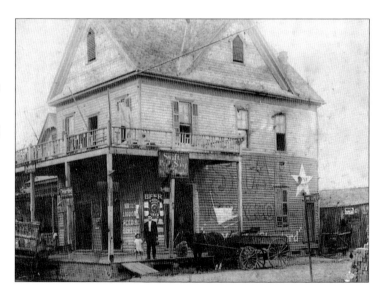

PALAZZO FAMILY GROCERY. Located at the corner of West Dallas and Lamb Streets, the Sam Palazzo family home was built in the late 1890s. The family lived upstairs and ran a general grocery below. Members of the Patrenella family today operate an Italian restaurant in Houston. In this picture, Sam Palazzo is holding the hand of Nita Palazzo Patrenella. (Courtesy of Sammy Patrenella.)

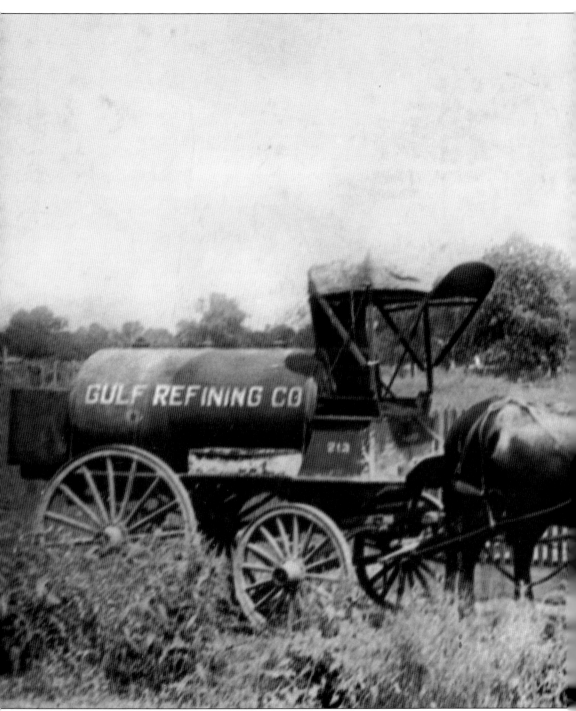

THE PALAZZO HOME. Located at 2704 West Dallas, this building was home to John Palazzo and members of his extended family. Built in a shotgun style, its rooms adjoin without hallways. The Palazzo family, shown from left to right, is Bessie Palazzo (Patrenella), Bonnie Palazzo (Zazarna), John Palazzo, Nita Palazzo (Carrabba), and Nita Palazzo. Located where Vincent's Restaurant is today, the Palazzo home in this picture illustrates the beginnings of a Houston restaurant legacy

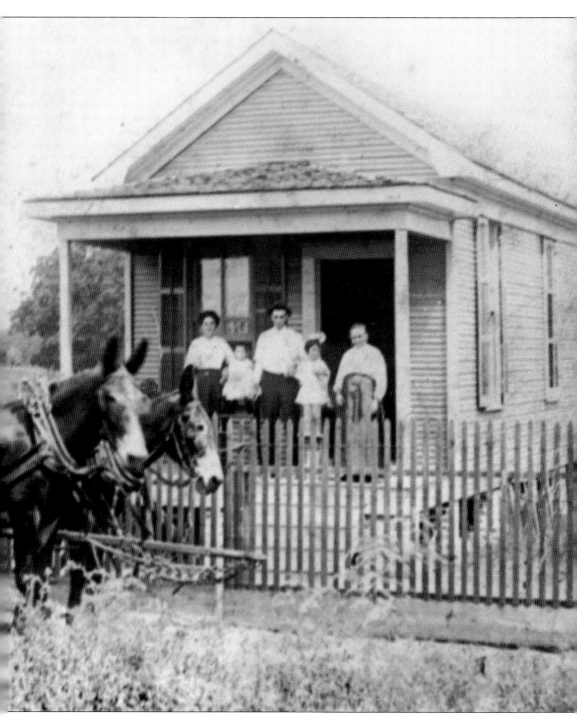

that continues today. John Palazzo was a self-employed kerosene salesman who made deliveries using a mule-drawn kerosene tanker. In the 1890s, one or two horses, depending on the size of the tank and weight of the load, usually pulled tank wagons. The usual daily sales and delivery radius for deliveries was more or less 12 to 15 miles. (Courtesy of Sammy Patrenella.)

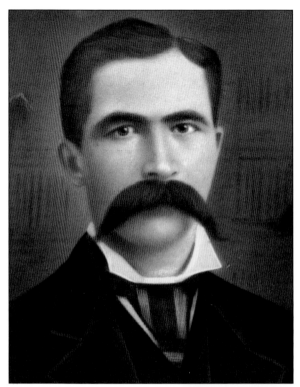

MICHELE DEGIORGIO AND URSULA CIULLA DEGIORGIO. The DeGiorgios, who changed their name to DeGeorges, came from Bisacquino near Palermo, Sicily, and arrived in New Orleans in 1882. Ursula was a proficient homemaker and a volunteer in church and civic organizations. Michele worked in the sugar cane fields for 50¢ a day, then was a supervisor for an Orange, Texas, sawmill. Settling in Houston in 1884 with $700 savings, Michele first operated a grocery store and was a delivery driver for Magnolia Brewery. After Americanizing his name, DeGeorge began his real estate career building rental houses and eventually built the DeGeorge Hotel at 1418 Preston Street and Auditorium Hotel at 701 Texas Avenue. At the time of his death, he was one of the wealthiest Italian immigrants in the Southwest. (Both courtesy of Michaeline Lusk Norton.)

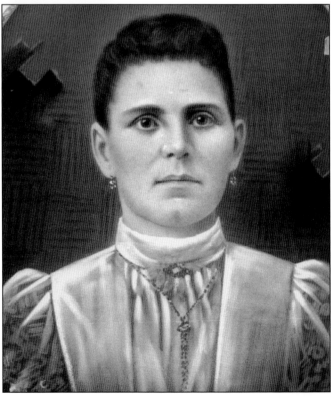

ANNUNCIATION CATHOLIC CHURCH. The second oldest established Catholic church in Houston, Church of the Annunciation, is on the corner of Texas Avenue and Crawford Street. The church was completed and dedicated September 10, 1871. From 1881 to 1884, architect Nicholas Clayton added the German twin towers and other features. Clayton also designed the enlargement in 1895. For over 140 years, the spire of this church has been a part of the Houston skyline. (Copyright © Judith-Ann Saks, all rights reserved.)

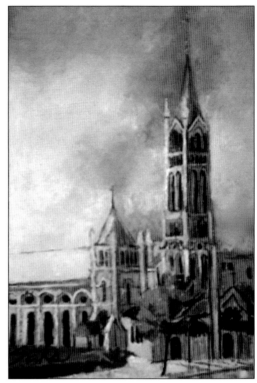

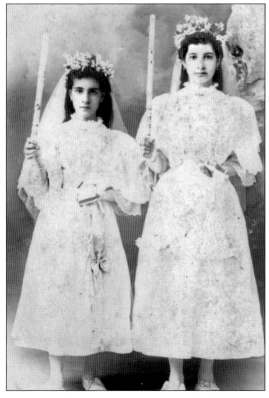

FIRST COMMUNION AND CONFIRMATION. Taken in 1897, this picture is of Lena Mary DeGeorge on the left and her sister Rosalie DeGeorge at their First Communion and Confirmation ceremonies. The DeGeorge family, originally from Sicily, were devoted Catholics and members of the Annunciation Catholic Church at 1618 Texas Avenue. (Courtesy of Michaeline Lusk Norton.)

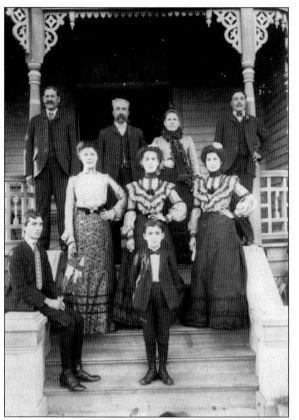

THE DEGEORGE HOME AT 918 BAGBY STREET. Built in 1895 by Michele for his wife, Ursula Ciulla, and their six children (Joseph, Rosalie, Lena, Gasper, Bernard, and Mary), this Victorian home was located on a compound that included rental houses, a corner grocery store, a carriage house, and a laundry house. Ursula maintained a 10-room Victorian- and Italian-style home with a distinguished turret and wraparound porches on both floors. The home was furnished with highly carved, expensive furniture of many periods, many pieces imported from Italy. Originally the families lived above the grocery store in a two-story wood structure with a Western facade. As a deliveryman for the Magnolia Brewery, Michele had the route advantage, and his grocery store had the reputation for selling the coldest beer in town. (Both courtesy of Michaeline Lusk Norton.)

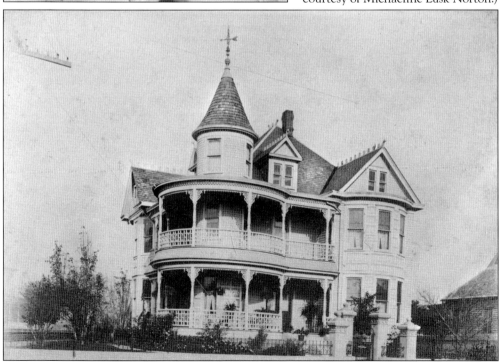

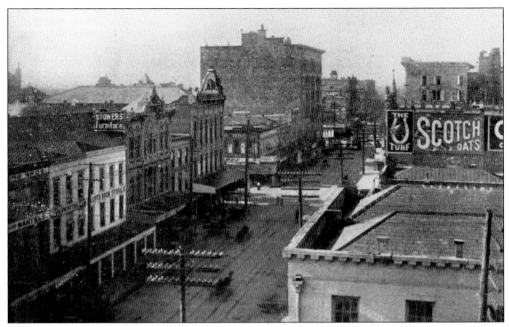

Prairie Avenue. The Turf Club was recognized as the headquarters for fine wines, liquors, and cigars and with a splendid restaurant in addition. The Turf Exchange Saloon and Restaurant had the only telegraph in Houston besides Western Union, which was used for betting on national horse races and listening to prizefights over the wires. Charles Miles Lusk was proprietor and manager of the Turf Club. (Courtesy of Robert P. Cochran.)

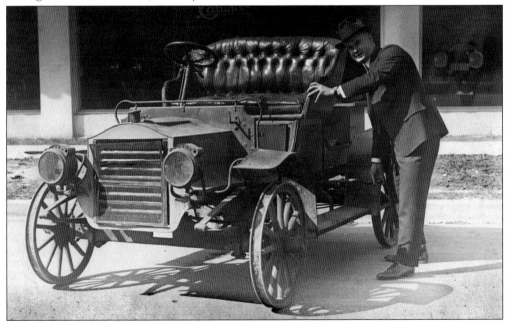

A 1902 Cadillac. Dr. Charles Michael Lusk stands with his father Charles Miles Lusk's 1902 Cadillac. This was one of the first cars to drive the Houston thoroughfares. It was powered by a 10-horsepower, single-cylinder engine and cost $750. Houstonians could see this car when Charles Miles Lusk drove it to his establishment, the Turf Club. (Courtesy of Michaeline Lusk Norton.)

THE MAGNOLIA CITY. Houston was once an area with hundreds of sweet, fragrant magnolia trees. Journalists visiting Houston prior to 1900 wrote accounts of the beauty and serenity of the magnolia groves. Urban sprawl put an end to the natural magnolia forests, but the nickname still is used and signifies a time period in Houston. (Courtesy of Gail M. Miller.)

HOTEL BRAZOS. The Hotel Brazos was across the street from Grand Central Depot. It prided itself on a variety of outstanding interiors. It had a ladies' parlor and section of the main lobby, which featured such items as comfortable lounge furniture, a baby grand piano, fireplace, writing desk, and fresh-cut flowers. Other special interiors were a beautiful loggia, marble corridors, enclosed court, and attractive dining room. (Courtesy of Gail M. Miller.)

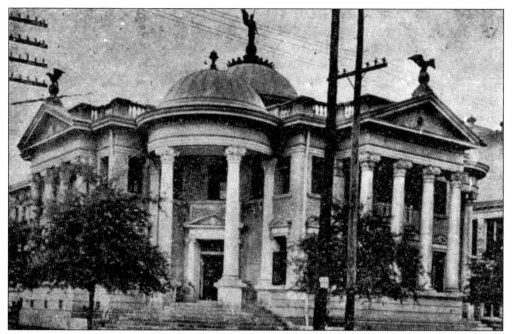

CARNEGIE LIBRARY. City appropriations for acquisitions and a free public reading room for all citizens began in 1899, when Andrew Carnegie agreed to donate $50,000 for a new building. Chartered in August 1900, the Houston Lyceum and Carnegie Library Association, with the help of the newly formed City Federation of Women's Clubs, raised funds to purchase an appropriate site. (Courtesy of Robert P. Cochran.)

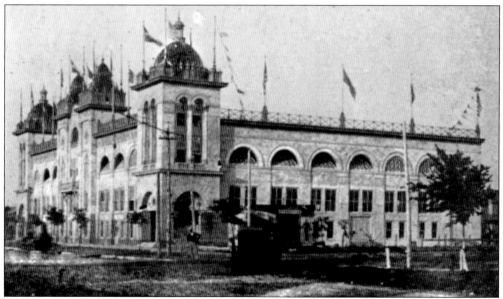

WINNIE DAVID AUDITORIUM. The auditorium featured such greats as pianist Ignaz Paderewski, ballerina Anna Pavlova, tenor Enrico Caruso, singer Marian Anderson, and Elvis Presley. In later years, wrestlers and road shows performed there. The Winnie Davis Auditorium was the largest modern convention hall in the South at its opening, with seating for 7,000, and cost $400,000 to build. (Courtesy of Robert P. Cochran.)

ELLA HUTCHINS SYDNOR. The wife of Seabrook Sydnor and the daughter of a mayor of Houston, Ella lived at 1416 Franklin Street. She was a descendant of Austin's Old Three Hundred colony and published a book, *Gems from a Texas Quarry*, under the name of Ella Hutchins Stewart. She was the first regent of the Lady Washington chapter of the Daughters of the American Revolution (DAR). (Courtesy of Beth Leney.)

THE RICE HOTEL. By 1899, this building had been named for William Marsh Rice, but it was still referred to as the Capitol Hotel. Here in the hotel's parlor was where Ella Sydnor held a meeting of women interested in starting a new chapter of the DAR. On November 14, 1899, the Lady Washington chapter was formed. It was the first chapter organized in Houston and the fifth in Texas. (Courtesy of Robert P. Cochran.)

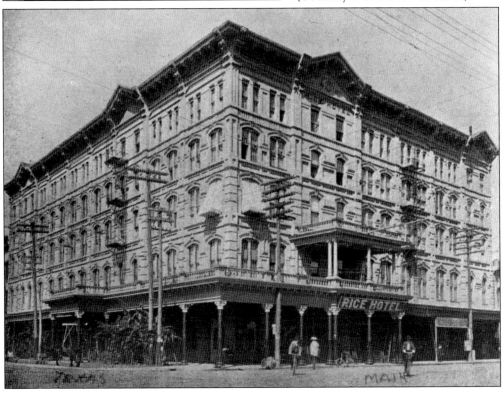

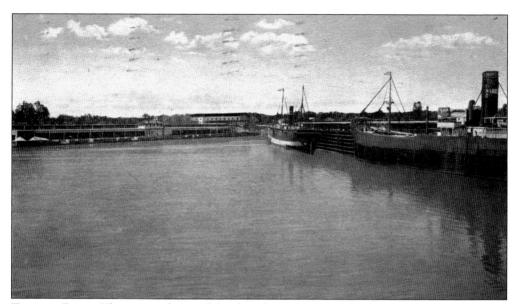

TURNING BASIN. The turning basin of the ship channel at Houston, which is the wonder of the maritime world, has been made navigable by deepening and widening an old river bed extending from the city limits of Houston to the Gulf of Mexico, thus allowing many international oceangoing vessels the ability to safely navigate to their destination of the Port of Houston docks. (Courtesy of Gail M. Miller.)

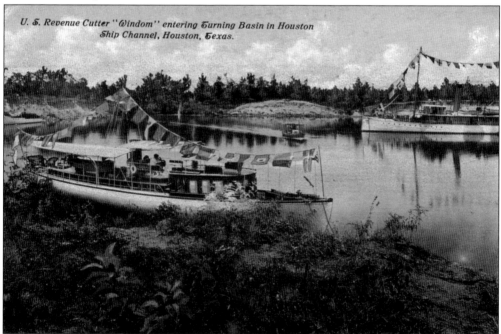

THE U.S. REVENUE SERVICE CUTTER WINDOM. Commissioned by the U.S. Revenue Cutter Service on June 30, 1896, the *Windom* was a steel-hulled, single-screw vessel with an engine capable of generating 800 horsepower. She carried one small-caliber gun. This cutter service was a forerunner of the modern U.S. Coast Guard and saw action during the Spanish-American War. (Courtesy of Gail M. Miller.)

A 100-BALE ARCH OF COTTON. Business as usual in downtown Houston is seen in this picture. Deliverymen are dropping off their loads on the left, while businessman stare up in amazement at the architectural feat being completed by the two men on top. A huge arch of round-bale cotton stands 16 feet high from sidewalk to sidewalk, spanning the entire street. An African American vendor has potatoes for sale, and women in their Victorian-style hats walk to destinations

unknown. The streets are paved and sidewalks bricked. The street lamps and the tiny hanging lights below the arch are electric. Houston has grown from a frontier town to a modern one by the end of the 1900s. Houston before oil was a fascinating place to live. (Courtesy of Dawn Fudge and the Last Concert Café.)

BIBLIOGRAPHY

Becker, Ann Dunphy. Gustave August Forsgard (1832–1919). Houston, TX: Beckers Books, 2002.
Cook, Ann, ed. *City Life 1865–1900: Views of America*. New York: Praeger Publishers, 1973.
Forsgard, Eddie Camille, and Robinette Smith Evans Forsgard. *Weaver Memories & Lineage 1800–2000*. Waco, TX: Evans and Forsgard, 2001.
Fox, Stephen. *Houston Architectural Guide*. Houston, TX: The American Institute of Architects/Houston, 1990.
Fuermann, George. *Houston: The Once and Future City*. New York: Doubleday and Company, 1971.
———. *Houston: The Feast Years*. Houston, TX: Premier Printing, 1962.
Houghton, Dorothy Knox Howe, et al. *Houston's Forgotten Heritage*. College Station: Texas A&M Press, 1991.
Johnston, Marguerite. *Houston the Unknown City, 1836–1946*. College Station: Texas A&M Press, 1991.
Kidd, J. C. *History of Holland Lodge No. 1 Ancient Free and Accepted Masons*. Houston, TX: Holland Lodge No. 1 Ancient Free and Accepted Masons, 1883.
Ladies Association of the First Presbyterian Church. *The Texas Cookbook*. Houston, TX: First Presbyterian Church, 1883.
McCulloch, Lou W. *Card Photographs*. Philadelpia, PA: Schiffler Publishing Company, 1981.
Newhall, Beaumont. *The History of Photography*. Boston: Little, Brown, and Company, 1982.
Platt, Howard. *City Building in the New South*. Philadelphia, PA: Temple University Press, 1983.
Red, Ellen Robbins. *Early Days on the Bayou 1838–1890*. Houston, TX: self-published, 1986.
Scott, Larry E. The Swedish Texas. Austin: University of Texas, 1990.
Smith, Ethel Mary Franklin. *Memoirs of Mollie McDowell (Mary Ann Nicholson 1843–1931)*. Austin, TX: National Society of the Colonial Dames of America, 1978.
Tidwell, Donavan Duncan. *A History of the Gray Lodge No. 329 A.F.&A.M. Houston, TX 1870–1970*. Fort Worth: Masonic Home and School of Texas, 1970.
Wilson, Ann Quinn. *Native Houstonians: A Collective Portrait*. Virginia Beach, VA: The Donning Company, 1982.

INDEX

Alderette, 101, 102
Annunciation Catholic Church, 80, 117
Bagby family, 40, 98, 104, 118
Baker, William R., 7, 14, 19
Bohemia, 16
Boyce, 23
Branard, Ada Elizabeth Connor, 13
Branard, Sgt. George Albert, 13
bridge, 8, 38, 71–73, 75, 91, 103
Bringhurst, 36, 64–67
Burke family, 17–21, 35, 38, 40, 65, 67, 81
Burke, Andrew Jackson, 7, 16, 18, 19
Bute family, 49, 85
Cade, James Robert, 7, 34, 35
Capitol Avenue, 7, 43–45, 51, 53
Civil War, 8, 16, 18
Cleveland, 53, 56, 57
Cochran, 39, 41
Columbia Tap Railroad, 37
Confederacy, 7, 10, 20
Congress Avenue, 10, 12, 42, 58, 59, 75, 77, 84, 86, 107
cotton, 8, 11, 23, 24, 38, 39, 44, 47, 52, 70, 74, 75, 93, 100, 124
Cushing family, 7, 11, 15–17, 35
DeGeorge family, 8, 116–118
Dowling, Richard ("Dick"), 10
Elsbury, 8, 43–45, 51
First National Bank, 39–41
Forsgard family, 7, 35
Fuqua, 8, 44, 50–55, 108
Garcia, Commissioner Sylvia R., 68
Geiselman, 50
Gillette-Fortrand Law Firm, 12
Glenwood Cemetery, 14, 50, 67, 81
Heiner, Eugene, 8, 47, 58, 74
Hood's Texas Brigade, 13
House family, 7, 13, 22–33, 37, 43, 45, 77
Houston Academy, 18, 41, 58, 65
Houston Light Guard, 79–81
Houston, Sam, 11
Howze family, 32, 33, 48, 96, 97
Lady Washington Chapter, NSDAR, 122
Lusk, 119
Main Street, 8, 10, 18, 42, 48, 55–58, 72, 77, 84, 85, 87, 92, 94, 96, 112
Mason, 14, 34, 35, 39, 63
McDowell, Mary Ann "Mollie" Nicholson, 22, 25
Moore, Mollie, 7
Palazzo, 113, 114
Patrenella, 113, 114
Pillot, 60, 106, 107
Presbyterian church, 18, 19
railroad, 14, 15, 17, 19, 20, 25, 34, 35, 37, 70, 81, 86, 87, 90, 91, 93, 97
Root, 38, 61–63
Sam Houston Park, 105, 106, 108, 109
Shepherd, 38, 39, 62
ship channel, 7, 75, 85, 92, 123
telegraph, 14, 105
trolley, 9, 94
Victorian, 11, 17, 39, 58, 73, 75, 86

Discover Thousands of Local History Books
Featuring Millions of Vintage Images

Arcadia Publishing, the leading local history publisher in the United States, is committed to making history accessible and meaningful through publishing books that celebrate and preserve the heritage of America's people and places.

Find more books like this at
www.arcadiapublishing.com

Search for your hometown history, your old stomping grounds, and even your favorite sports team.

Consistent with our mission to preserve history on a local level, this book was printed in South Carolina on American-made paper and manufactured entirely in the United States. Products carrying the accredited Forest Stewardship Council (FSC) label are printed on 100 percent FSC-certified paper.